D0842631

NO LONGER PROPERTY
OF ANYTHINK
RANGEVIEW LIBRARY
DISTRICT

CHURCHILL:
THE STATESMAN AS ARTIST

CHURCHILL

The Statesman as Artist

EDITED AND INTRODUCED BY
DAVID CANNADINE

BLOOMSBURY CONTINUUM
LONDON · NEW YORK · OXFORD · NEW DELHI · SYDNEY

BLOOMSBURY CONTINUUM
Bloomsbury Publishing Plc
50 Bedford Square, London, WC1B 3DP, UK

BLOOMSBURY, BLOOMSBURY CONTINUUM and the Diana logo are trademarks of
Bloomsbury Publishing Plc

First published in Great Britain 2018

Introduction Copyright © David Cannadine, 2018
Written works of Winston S. Churchill Copyright © The Estate of Winston S. Churchill, 2018
Paintings by Winston S. Churchill © Churchill Heritage Limited, 2018

David Cannadine has asserted his right under the Copyright,
Designs and Patents Act, 1988, to be identified as the Editor of this work

For legal purposes the Acknowledgements on pp. 167–8
constitute an extension of this copyright page. Every reasonable effort has been made
to trace copyright holders of material reproduced in this book, but if any have been
inadvertently overlooked the publishers would be glad to hear from them.

All rights reserved. No part of this publication may be reproduced or transmitted
in any form or by any means, electronic or mechanical, including photocopying,
recording, or any information storage or retrieval system, without prior permission
in writing from the publishers

A catalogue record for this book is available from the British Library

Library of Congress Cataloguing-in-Publication data has been applied for

ISBN: HB: 978-1-4729-4521-1; EPDF: 978-1-4729-4519-8; EPUB: 978-1-4729-4522-8

2 4 6 8 10 9 7 5 3 1

Typeset by Newgen KnowledgeWorks Pvt. Ltd., Chennai, India
Printed and bound in Great Britain by CPI Group (UK) Ltd, Croydon CR0 4YY

To find out more about our authors and books visit www.bloomsbury.com
and sign up for our newsletters

In memory of Mary Soames

CONTENTS

CONTENTS

LIST OF ILLUSTRATIONS

Paintings by Winston S. Churchill

1. Self-portrait, circa 1915. (© Churchill Heritage)
2. Plug Street, 1916. (© Churchill Heritage)
3. The gardens at Hoe Farm, 1915. (© Churchill Heritage)
4. Sir John Lavery in his studio, 1915. (© National Trust, Chartwell)
5. The Long Library at Blenheim Palace in 1916. (© Churchill Heritage)
6. The Blue Room at Port Lympne, circa 1921. (© Churchill Heritage)
7. The Long Gallery at Sutton Place, 1921. (© Churchill Heritage)
8. The Pyramids, 1921. (© Churchill Heritage)
9. Winter Sunshine at Chartwell, circa 1924. (© Churchill Heritage)
10. Trees at Mimizan, circa 1925. (© Churchill Heritage)
11. The Palladian Bridge at Wilton, 1925. (Royal Collection Trust / © Her Majesty Queen Elizabeth II, 2017)
12. The Great Hall at Blenheim Palace, circa 1928. (© Churchill Heritage)
13. Tea at Chartwell, circa 1928. (© Churchill Heritage)
14. The second Duke of Westminster with his lurcher Sam, late 1920s. (© Churchill Heritage)
15. Tapestries at Blenheim Palace, circa 1930. (© Churchill Heritage)
16. View of Monte Carlo and Monaco, circa 1930. (© Churchill Heritage)
17. Studio still life, circa 1930. (© Churchill Heritage)
18. Loch Scene on the Duke of Sutherland's Scottish estate, circa 1930. (© Churchill Heritage)

PREFACE

Most of this book consists of Winston Churchill's own thoughts on art, and the views of contemporary critics on him as an artist. These writings have never previously been gathered together, and that in itself is ample justification for the appearance of this volume. They tell us important things about Churchill, and about his reputation in his time; and while his own writings on art are, like most of his pictures, consistently buoyant, joyous and highly-coloured, he painted primarily to keep depression at bay, and also because it provided another outlet for the display of his extraordinarily creative gifts. Statesmen who are also artists are very rare, and Churchill is by a substantial margin the best documented of them.

Although I have long been fascinated by Churchill as one of the great historical figures of the twentieth century, my interest in him as a painter was only aroused when I was invited to deliver the Linbury Lecture at Dulwich Art Gallery on that subject, and it was further stimulated when I recorded a series that was broadcast on BBC Radio 4 entitled 'Churchill's Other Lives'. Accordingly, my first thanks are to Lord Sainsbury of Preston Candover and the Trustees of the Linbury Trust, and to Dr Ian Dejardin, the then Director of the Dulwich Picture Gallery, for inviting me to lecture on Churchill as an artist; and to Denys Blakeway and Melissa Fitzgerald, of Blakeway Productions, with whom I made 'Churchill's Other Lives'.

In researching Churchill the painter in the archives, I am once more indebted to Allen Packwood, Director of the Churchill Archive Centre at Churchill College, Cambridge, and his unfailingly knowledgeable and helpful colleagues. I am grateful to Dr Charles Saumarez Smith, Secretary and Chief Executive of the Royal Academy, and to Mark Pomeroy, the Academy's Archivist, for their assistance and advice. I also thank Bart H. Ryckbosch, the Glasser and Rosenthal Family Archivist at the Art Institute of Chicago, and Teri Edelstein for putting us in touch. Once more, the assistance and forbearance of Dr Martha Vandrei have been invaluable.

In working on this project, I have been enormously fortunate in my two editors at Bloomsbury, Robin Baird-Smith and Jamie Birkett, who have seen a complex book through to publication with great resourcefulness, dedication and skill, and I also express my thanks to their colleagues, Sutchinda Thompson, Graham Coster, Hannah Paget and Chloe Foster. I am grateful to Curtis Brown, who represent the Churchill Estate, and in particular to Gordon Wise, to the National Trust staff who work at Chartwell, and to Mr Randolph Churchill for his generous help and encouragement. Thanks to them, no less than to Churchill himself, this book reveals his life in art more vividly than ever before.

David Cannadine
Swedish Collegium for Advanced Study
Uppsala
30 November 2017

INTRODUCTION

by David Cannadine

'Winston sees everything in pictures'

Lord Moran[1]

DURING THE LAST YEARS of his life, Winston Churchill was often acclaimed as 'the greatest Englishman of his time' and 'the saviour of his country', and he is still regarded by many as 'the most remarkable human being ever to have occupied 10 Downing Street', and as the 'greatest Briton ever to have lived'.[2] Such encomiums, although not universally shared, rightly recognize the extraordinary longevity and outstanding achievements of his public life, as a politician, party leader, prime minister and global statesman, but they also bear witness to the unusual range of Churchill's extra-curricular activities and accomplishments, as (among other things) a soldier and journalist, historian and biographer, bricklayer and bon viveur, polo player and racehorse owner. With the possible exception of Mr Gladstone, no British prime minister of modern times has inhabited so many varied and different hinterlands, or done so with such energy, vigour, brio and élan. And on any list of what Churchill called his 'hobbies', painting eventually came to rank very high, both in terms of the therapy and pleasure that it gave him, and as an important aspect of his latter-day reputation as 'the largest human being of our time'.[3] For while he never claimed to be a great artist, painting would

1

come to occupy a uniquely important place in his recreational repertoire, and it also furnished an essential element of his latter-day public persona as a veritable Renaissance man of exceptionally varied accomplishments. Yet like so many aspects of his long life, Churchill's involvement with oils, brushes, easels and canvasses was more complex and revealing than his own writings on these subjects suggest, and there is more to say about him as an artist than has yet been recognized.[4]

I

Among the hundreds of paintings Churchill completed during his lifetime were many of the interiors and exteriors of Blenheim Palace, and they were one indication of the abiding importance to him of his ancestral home [Figs. 5, 12, 15]. He had been born there in a small ground floor room in November 1874; he proposed to Clementine Hozier in the Temple of Diana in its gardens in the summer of 1908; and he was buried nearby in Bladon churchyard in January 1965. Blenheim also helps explain Churchill's fierce sense of dynastic pride and family loyalty, his preference for a settled, hierarchical social order, and his belief in the Whiggish narrative of providential national greatness which Vanbrugh's monumental mansion triumphantly celebrated and proudly proclaimed.[5] Less often noticed is that during Churchill's early years, Blenheim was still one of the great treasure houses of Britain, meriting comparison with Woburn, Chatsworth, Boughton or Burleigh, for it had been filled with great art collected by John Churchill, first Duke of Marlborough.[6] But the family finances had been much diminished since his day, and between 1884

and 1886, the Blenheim Old Masters, including canvasses by Raphael, Breughel, Rembrandt and Holbein, were dispersed in some of the most extraordinary art sales of the nineteenth century.[7] To be sure, a few important works survived, including the portrait of the fourth duke and his family by Sir Joshua Reynolds, which would later be joined by the companion picture which the ninth duke commissioned from John Singer Sargent, some of whose paintings Churchill would later copy [Fig. 33].[8] But the disappearance of virtually all the best art from Blenheim during Churchill's adolescence may explain why he never evinced any serious interest in European Old Masters, or in traditional English portraiture.

This depletion may also help explain why Churchill would later claim that he had demonstrated no appreciation of art at any time during the first forty years of his life, and that his own creative endeavours had been confined to a few drawings reluctantly and unsuccessfully undertaken while he was at school and serving in the army. Such was his recollection, as reported years later, by Clementine Churchill, and as recorded by his doctor, Lord Moran:

> When Winston took up painting in 1915, he had never up to that moment been in a picture gallery. He went with me … to the National Gallery [in London], and pausing before the first picture, a very ordinary affair, he appeared absorbed in it. For half an hour, he studied its technique minutely. Next day, he again visited the Gallery, but I took him in this time by the left entrance instead of the right, so that I might at least be sure that he would not return to the same picture.[9]

Before that visit, Churchill's closest encounters with art had been his early attendances, beginning in 1908, at the Royal Academy banquets, held in Burlington House on Piccadilly, which were a highlight of the London season and inaugurated the Academy's annual summer exhibition. But he was invited to these gatherings as a member of the Liberal government, not because he was expected to have anything significant to say about sculpture or painting or architecture. When Churchill delivered his first two speeches, in 1912 and 1913, he did so as First Lord of the Admiralty, replying the toast of 'the Navy', and on both occasions he was primarily concerned to assert the continuing and urgent need to maintain Britain's formidable sea power and maritime might. 'Modern ships', he noted in his second speech, almost by way of an afterthought, 'do not afford much ground for artists to work upon.' 'We cannot', he went on, speaking for the Navy as a whole, but also for himself, 'on the aesthetic or the artistic side claim any close acquaintanceship with the Royal Academy.'[10]

Churchill's middle-aged indifference to art was all of a piece with the account that he would later give, in *My Early Life* (1930), of his academic shortcomings as a schoolboy, where he depicted himself as having been hopeless at mathematics and incapable of mastering Latin or Greek.[11] High learning and high art had not been for him then, and although he had worked hard to make up for his educational shortcomings during his days as a subaltern in late nineteenth-century India, Churchill never fully overcame these cultural limitations and intellectual deficiencies.[12] His knowledge of European languages did not advance much beyond idiosyncratic yet workable schoolroom French. His

models in history-writing were not the innovative scholars of his own time, but two men long dead, namely Gibbon and Macaulay. He did not turn hungrily to the works of philosophers, economists or social scientists, and showed no great interest in engaging with Marx or Freud, the great intellectual figures of his youth and middle age.[13] His taste in music never developed further than rousing hymns, Gilbert and Sullivan, Viennese operetta, military marches, 'Land of Hope and Glory' and 'Rule Britannia'.[14] And he was at best indifferent, at worst hostile, to modern, abstract art as it developed during his lifetime in the hands of such innovative masters as Chagall and Picasso. As such, Churchill was neither an intellectual nor an aesthete, but rather a man of action and of affairs, and he always felt insecure when dealing with people such as Balfour, Asquith, Curzon and F. E. Smith, who had benefited from being educated at Oxford or Cambridge Universities.[15]

Yet while it was – and is – easy to dismiss him as being culturally uninformed, intellectually incurious and aesthetically unsophisticated, Churchill also possessed remarkably potent mental machinery, albeit academically untrained, and for a public figure he was also unusually creative and imaginative. Kenneth Clark was not alone in being impressed by the force of his intellect and the range of his interests. 'I have', he recalled, 'never been frightened of anyone except Churchill ... He was a man of a wonderful and very powerful mind.'[16] All his life, Churchill would be fascinated by science, gadgetry and technology, and even if this owed more to Jules Verne and Lord Cherwell than to Einstein or Rutherford, it was a real and genuine preoccupation, which would be appropriately commemorated in the establishment of

Churchill College, Cambridge, in 1960, which was originally conceived as a British answer to the Massachusetts Institute of Technology.[17] He was very well read in the conventional literary culture of his class and his time, namely 'the Bible, Shakespeare, Milton, Scott, Dickens and a little Trollope, topped off with Rudyard Kipling', and to almost the very end of his life, he could recite many lines from Shakespeare and the Romantic poets.[18] From an early age, Churchill was also enthralled by the theatre, he was an avid reader of contemporary fiction, and among those elected to the Other Club, which he had co-founded in 1911 with F. E. Smith, were the writers Arnold Bennett, Anthony Hope, John Buchan and P. G. Wodehouse. Another member was H. G. Wells: despite his maverick, radical views and their resulting political disagreements, Wells's fascination with science and literature mirrored – and may have encouraged – Churchill's own.[19]

But it was also clear to many observers and contemporaries, from General de Gaulle to A. L. Rowse, that 'the artist' in Churchill was 'almost as strong as the politician and soldier', and he owed this to his Spencer forebears, who were more aesthetically inclined than his military-minded Marlborough ancestors, and also to his mother's family, the Jeromes of New York City.[20] Perhaps for this reason, the artistic strain among his relatives was strongly pronounced during the twentieth century. Churchill's nephew, John, who was the eldest son of his younger brother Jack, made a successful career as a sculptor, and as a painter of murals, portraits and frescoes. Churchill helped him on his way, employing him after the Second World War to decorate the summer house at Chartwell with scenes of the Duke of Marlborough's great victories, and John would also embellish

a temple at Blenheim Palace for the tenth duke [Fig. 36].[21] Churchill's cousin, Clare Sheridan, who was the daughter of Lady Randolph Churchill's elder sister, was an accomplished sculptor. One of her largest works was a bust of Lenin that was two and a half times life size, and her ardent support of the leader of Communist Russia scarcely endeared her to her cousin Winston. But she also sculpted two memorable (but smaller) busts of him, one in the 1920s, and a second in the early 1940s.[22] And in later generations, Churchill's daughter Sarah was both an actress and a painter, albeit of sadly unrealized promise, while his grand-daughter Edwina Sandys is a renowned sculptor and artist.[23]

Although widely distributed among his descendants and relatives, these creative impulses were especially pronounced in the case of Churchill himself. From an early age, he seems to have been gifted with the heightened perception of the artist, to whom no scene, no event, no individual was ever dull or humdrum or commonplace. This was most famously true in his use of the English language, which he handled in his conversation, his speeches, his journalism and his books with a sure touch, a sensuous feel and an imaginative brilliance, as he delighted in strong nouns, vivid adjectives, rich imagery, polished antitheses, glowing phrases and powerful rhetorical effects. There was nothing dull or humdrum or commonplace about Churchill's choice or use of words, and although his paintings lacked the stately splendour, the 'formal magnificence' and the heroic grandeur of his greatest orations, they strikingly resembled them in other ways.[24] For, like his speeches, they were often bright, warm, vivid, highly-coloured and illuminated creations, full of arresting contrasts between the light and the dark, the

sunshine and the shadows. Not surprisingly, then, when Churchill later came to write about painting, he revealingly described the ideal finished canvas as resembling 'a long, sustained, interlocking argument', characterized by 'a single unity of conception' – words that would equally apply to the composition and the structure of his finest orations.[25]

Moreover, Churchill not only possessed an unusually powerful rhetorical imagination, but he was also gifted with an equally strong visual sense. Despite his later insistence to the contrary, the drawing classes he took at Harrow and Sandhurst made a lasting impact.[26] Even in his earliest books, describing his youthful adventures on the frontiers of the British Empire, Churchill displayed a remarkable capacity to summon up a scene, to evoke landscapes, to describe towns and villages, and to capture the excitement of military campaigning and armed confrontation. He insisted that his books should be illustrated with drawings, photographs and detailed maps of the battles he witnessed or fought in, and he would later admire T. E. Lawrence's *Seven Pillars of Wisdom* for its illustrations and visual effects.[27] From an early age, Churchill was also fascinated by political cartoons, on which he would later write with considerable perceptiveness, and he especially admired the work of David Low.[28] During the 1930s he devised several screenplays for Alexander Korda and his London Film Productions studio (though none was ever made into a film); he befriended Charles Chaplin, whom he met in Hollywood and who later visited Churchill at Chartwell (when it soon became clear that Chaplin's political views were closer to Clare Sheridan's than to his host's) [Fig. 35]; he wrote an essay in 1935 comparing the relative merits of silent and talking films (preferring, perhaps

unexpectedly, the former to the latter); and during the Second World War, late-night films at Chequers were his prime form of relaxation (but also a stimulus to his strategic thinking).[29]

For Churchill, the visual was at least as important as the verbal, and in his speeches and his writings the two often converged. Like Macaulay, he was unusually gifted in the art of vivid and arresting 'word-painting'. 'The whole scene', he observed, when describing the Battle of Omdurman in one of his earliest books, 'flickered exactly like a cinematograph picture.' 'I shall try in this and the following letters', he later wrote from South Africa in the *Morning Post*, 'to paint you a picture of the [Boer] war.'[30] Here, at greater length, is another early example of Churchill's remarkable capacity to evoke a landscape in striking and highly-coloured prose. It is a passage from his only novel, *Savrola* (1900), and it describes the broad panorama that could be glimpsed by the heroine from the presidential palace in the capital of the fictional republic of Laurania:

The scene which now stretched before her was one of surpassing beauty. The palace stood upon high ground commanding a wide view of the city and the harbour. The sun was low on the horizon, but the walls of the houses still stood out in glaring white. The red and blue tiled roofs were relieved by frequent gardens and squares, whose green and graceful palms soothed and gratified the eye ... Many white-sailed smacks dotted the waters of the Mediterranean Sea, which had already begun to change their blue for the more gorgeous colours of sunset.[31]

Such vivid and richly-pigmented words anticipate the many harbour scenes along the French Riviera and the Mediterranean coast that Churchill would later so fondly depict. Having earlier created such pictures on the page, he would subsequently depict them in oils [Fig. 16].[32]

Churchill did not begin painting until his fortieth year, but his family background and his own talents and temperament provide many clues and pointers as to how and why he made a success of it when he eventually did pick up a paintbrush. Yet as with many aspects of his life and career, Churchill's artistic endeavours need to be set and understood in a broader context. As a soldier in India, he had devoted his leisure hours to playing polo and to reading as many learned books as he could get his hands on. Had he been less focused on horses and belated self-improvement, he might equally have taken up painting, because this was something that many soldiers did.[33] As Churchill had already discovered at Sandhurst, learning to draw, and to appreciate terrain and topography from a military point of view, were essential parts of an officer's training, while the long days of leisure, often spent in unfamiliar and picturesque imperial locations, encouraged many soldiers to take up their sketchbooks or paintbrushes to help while away the time. One such soldier-artist had been the American general and president Ulysses S. Grant, who began painting while a cadet at West Point during the early 1840s; another was General Lord Rawlinson, with whom Churchill would go on a canvas-covering holiday in France in March 1920.[34] During the Second World War, several high-ranking military men on the Allied side were painters, including Generals Eisenhower, Auchinleck and Alexander (and Eisenhower

would complete a portrait of Churchill, from photographs, during his presidency). As a soldier-turned-artist, Churchill was neither unusual nor unique: but he was a better artist, and became more famous than any of his contemporary practitioners.[35]

Just as many soldiers painted, so many depressives sought solace in creativity. Writers who battled with despair have included Edgar Allen Poe, John Keats, Charles Dickens and Ernest Hemingway, while Charles Darwin and Tchaikovsky were similarly afflicted. Many artists were blighted by melancholy temperaments, among them Michelangelo, Van Gogh, Gauguin and Jackson Pollock. Among earlier statesmen, the father of Frederick the Great, King Frederick William I of Prussia, took up painting as an antidote to depression, and so, in more recent times, has President George W. Bush, as a way of coming to terms with his responsibility for the casualties in the Iraq War.[36] In Churchill's case, 'inborn melancholia' was a hereditary condition in the Marlborough family with which at least five dukes were afflicted, and early in his time in the House of Commons, he learned that something he called the 'black dog' would never be far away. One of the reasons Churchill worked so hard for so much of his life, and developed so many hobbies and additional ways of keeping busy, was because constant activity during his waking hours seemed the best means to hold the misery and despair brought on by the 'black dog' at bay. And when, in enfeebled old age, he was no longer able to summon up the energy to stay active, he seems to have descended into a sad twilight of almost perpetual gloom.[37] But from the late 1910s to the late 1950s, painting was one of the most successful stratagems that Churchill devised for banishing depression. And as is

well known, it was during the darkest time of his political life, when the 'black dog' tormented him as never before, that he first took up his brushes.

II

During the summer of 1915, Churchill's spirits were at their lowest ebb in the aftermath of the disastrous troop landings in the Dardanelles at Gallipoli. There were large losses of life, and the British and imperial forces were eventually compelled to withdraw. As the most ardent advocate of what became this doomed operation, Churchill bore the brunt of the blame for the fiasco, and when Asquith was forced to reconstruct his government in May 1915, Churchill was compelled to resign as First Lord of the Admiralty, and was fobbed off with the sinecure post of Chancellor of the Duchy of Lancaster. Out of power, and very soon to be out of office, he fell into a depression so severe and so protracted that Clementine feared he would die of the grief which was hauntingly depicted by William Orpen in the portrait of Churchill he completed at that time.[38] Shunned by the political establishment, Winston and Clementine sought refuge at Hoe Farm, a small country house they rented in Surrey, where Churchill's younger brother Jack and his wife Gwendeline (known as 'Goonie'), often came to stay. Goonie was an accomplished water-colourist, who brought her brushes and easel with her, and on one such visit she persuaded Churchill to try his hand at painting [Figs. 3, 34].[39] He was immediately captivated, and soon changed to oils as being a stronger and more robust medium than watercolours. He sent Clementine to nearby Godalming to buy him paints, and on his return to London he opened an account

with Roberson's, the artist's suppliers in Long Acre, where he made regular purchases of paint, turpentine, canvasses, easels and other materials.[40] Hence, too, those first visits to the National Gallery, as he sought to study and learn from the techniques of the great artists of the past.

During these early years, Churchill experimented with a wide variety of styles and subjects. One of his first efforts was a searing self-portrait, half-eclipsed in a black-dog-like shadow, and vividly conveying the depression and isolation against which he was struggling [Fig. 1]. At the end of 1915, Churchill resigned from the government, re-joined the army, and briefly commanded a battalion of the Royal Scots Fusiliers at Ploegsteert on the borders of France and Belgium. Now a painter as well as a soldier, he took his brushes and canvasses with him, and early in 1916 he completed several sombre pictures of the devastated buildings and war-torn countryside of Flanders [Fig. 2]. 'I think', he wrote to Clementine at this time, 'that [painting] will be a great pleasure and resource to me – if I come through all right.'[41] Churchill did, indeed, survive, his political fortunes gradually began to improve, he returned to government in 1917 as Minister of Munitions, and the Great War ended the following year. As his spirits revived, Churchill turned his artistic attention to more cheerful and optimistic subjects, increasingly concentrating on those warm, brightly-lit landscapes which banished depression rather than expressed it, and offered an escape from the pressures of public affairs. This change in his painterly priorities was vividly demonstrated in the canvasses he completed in Cairo in March 1921, when as Colonial Secretary he presided at a conference which created the new nations of Iraq and Transjordan (under British

control). The pictures Churchill produced of the Pyramids were sun-drenched and brightly-lit, and they were the most vivid and cheerful works he had yet completed [Fig. 8]. By this time, he had fallen in love with the Impressionists' use of light and colour, and their works, along with those of Joseph Mallord William Turner, would henceforward be his inspiration among painters of the past. As he would later put it: 'light is life', and what better antidote to the 'black dog' could there be than that?[42]

While seeking to improve as an artist, Churchill not only visited galleries to learn from the great painters of the past, but also sought advice from those who were living. The first was Sir John Lavery, who was a neighbour of Churchill's in the Cromwell Road, where he and his family had gone to live after he had been forced to leave the Admiralty. In the autumn and winter of 1915, Churchill and Lavery often painted together in Lavery's studio, and each produced portraits of the other working at their easels [Fig. 4]. Lavery's wife Hazel was also an accomplished artist, and it was she who urged Churchill never to be in awe of an empty canvas; while her husband considered that had Churchill 'chosen painting instead of statesmanship, I believe he would have been a great master with the brush, and as President of the Royal Academy would have given stimulus to the art world'. Churchill and Lavery became and remained close friends, as did their wives (and the Laverys also played a part in bringing Churchill and Michael Collins together when both were involved in negotiating the post-war Irish Treaty). 'I have not made much headway in painting,' Churchill wrote to Lavery from Cannes in January 1923, 'and should greatly have valued the stimulus of your presence and example

… I have been four or five days trying to do some pretty reflections of bright-coloured ships in the clear water of the harbour. I should have liked to have seen you splash them on.'[43]

Later in the same decade, Churchill was introduced to Walter Sickert, whom Clementine had known when she was a girl living with her mother in Dieppe. In 1927, Sickert renewed his acquaintance with her, and also established a brief but influential friendship with her husband. For the next two years he offered Churchill advice on how to prepare his canvasses, as well as demonstrating his own techniques for the handling and laying-on of paint. Even more importantly, Sickert taught Churchill how to work from photographs, either as preliminary documents for a painting, or as aides-memoire to use in his studio when completing a landscape he had begun on-site but left unfinished on returning home. 'I am really thrilled,' Winston wrote to Clementine from Chartwell in September 1927, 'by the field he is opening to me. I see my way to paint far better pictures than I ever thought possible before. He is really giving me a new lease of life as a painter.'[44] As a result of Sickert's tutelage, Churchill also went back to painting occasional portraits, but now basing them on photographs; they would never form a major component of his artistic oeuvre, although he rendered a memorable image of Clementine using this technique as late as 1955 [Figs. 13, 14, 30]. Like Lavery, Sickert also painted Churchill's portrait, but neither Clementine nor Winston liked the result, on the grounds it made him look like a bookie, and after two years, the friendship fizzled out.

Yet Churchill seems genuinely to have relished the company of artists, not only as a welcome break from his

political friendships (and antagonisms), but also for its own sake. He liked art talk and painterly conversation, several artists became lifelong friends, and he would later be deeply saddened by the deaths of Hazel Lavery and Sir William Orpen.[45] During the inter-war years, Orpen, Lavery, Sir Alfred Munnings and Sir William Nicholson would all be elected to the Other Club – membership of which Churchill regarded as virtually the highest form of recognition that could be bestowed on anyone, and where the conversation was animated, boisterous and uninhibited.[46] He was also an admirer of the work of Sir Edwin Lutyens, another member of the Other Club, who would serve as President of the Royal Academy from 1938 to 1944. During the 1930s, the young Kenneth Clark, then Director of the National Gallery, would also become a friend: Churchill invited him down to Chartwell, and dined regularly with him at the Clarks' grand house at 30 Portland Place. They had further dealings throughout the Second World War, especially while Clark worked at the Ministry of Information, and they remained in touch thereafter. Clark would be one of the dinner guests at 10 Downing Street when Churchill suffered a major stroke in July 1953; he would advise Churchill on which pictures to send to the Royal Academy for display in its Summer Exhibitions; and he would recommend Graham Sutherland to paint the ill-fated portrait, commissioned by the Houses of Parliament, to mark Churchill's eightieth birthday.[47]

By the time he was established at Chartwell, the Kent country house which he bought in 1922, painting had become an essential part of the settled life Churchill now craved: if the weather was good, he would depict exterior views of the house [Figs. 9, 24]; if bad then he would paint

still-lifes – fruit, flowers or bottles – inside [Figs. 17, 19];
and he soon established his own studio in one of the out-
buildings. Across more than four decades, Churchill would
eventually complete some five hundred canvasses – an aston-
ishing output, given the many other calls on his time, energy
and imagination. Indeed, by the inter-war years, painting had
come to rank second to writing among his many non-political
activities. But there were two significant differences between
them. Churchill wrote for serious public purposes: to cele-
brate his family, to vindicate his political record, to intervene
in the political issues of the day, and to make the substantial
sums necessary to finance his lavish style of life. By contrast,
he painted entirely for therapy and enjoyment: whereas he
took pride in being a professional writer, he always regarded
himself as merely an amateur artist, and while he wrote for
money, he never intended to sell his 'little daubs' to increase
his income.[48] Moreover, while Churchill spent most of his
waking hours talking incessantly, preparing and making his
speeches, delivering monologues at the lunch- and dinner-
table, and dictating his journalism and his books, painting
was the only activity he seems to have carried out in concen-
trated peace and complete *silence*. It absorbed him for many
continuous hours, taking his mind off everything else, and
off everybody else, too – which was why he found it so thera-
peutic. Even in his later years of fame and travel, when his
expeditions with brushes and paints were accompanied by a
large entourage, he would remain focused and hushed before
his easel.[49]

Although Churchill painted primarily for therapy,
pleasure and relaxation, his new hobby soon became public
knowledge, albeit in a minor sort of way. In January 1921,

he exhibited a number of his early canvasses in the Galerie Druet in Paris, under the pseudonym of Charles Morin, where four of the five landscapes on display were bought for £30 each. Four years later, he won an amateur art competition held at Sunderland House in London, where the judges were the painter Sir Oswald Birley, the dealer Joseph Duveen and Kenneth Clark.[50] Seeing the journalistic possibilities, Churchill also set down his thoughts on painting in two articles which appeared in the *Strand* magazine, published in December 1921 and January 1922. Clementine, who was often more concerned about her husband's reputation than he was himself, feared that such '*naif* or conceited' pieces, by someone who had never been trained to paint, might 'vex' the artistic establishment, whose members would reply, 'You do not yet know enough about art.' 'All that you say about the article on painting,' Churchill rather breezily responded, 'I will carefully consider' – and then proceeded to disregard Clementine's advice completely. 'An article by Mr Balfour on golf or philosophy, or by Mr Bonar Law on chess, would be considered entirely proper,' he replied, and his pieces on painting would be in a similar vein. They would be 'very light and amusing, without in any way offending the professional painters'. For Churchill's aim was 'to encourage other people to make an effort and experiment with the brush and see whether they cannot derive some portion of the pleasure which I have gained in amateur painting'.[51]

Although self-centred and egotistical, Churchill wrote these articles with uncharacteristic humility and self-deprecating candour, albeit with recognizable brio and relish, and some characteristically vivid word-smithing. He gave a highly selective account of how he had come to take up

Churchill Heritage

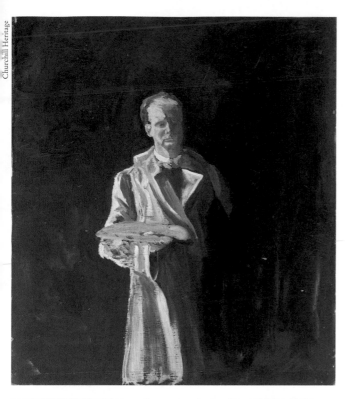

1. Self-portrait, c.1915, vividly depicting the 'black dog' of depression by which Churchill was blighted in the aftermath of the Dardanelles disaster.

2. Plug Street, 1916, painted when Churchill was on active service on the Western front at Ploegsteert, which was known as 'Plug Street' to the British troops.

Churchill Heritage

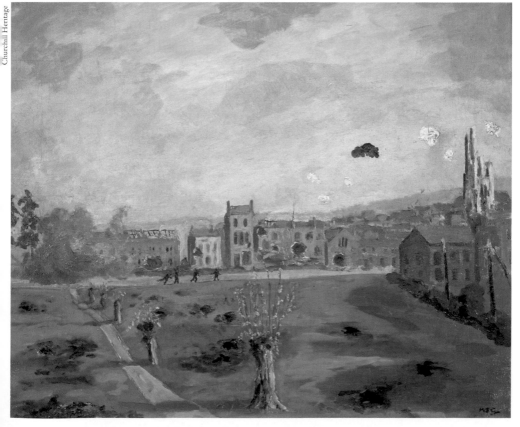

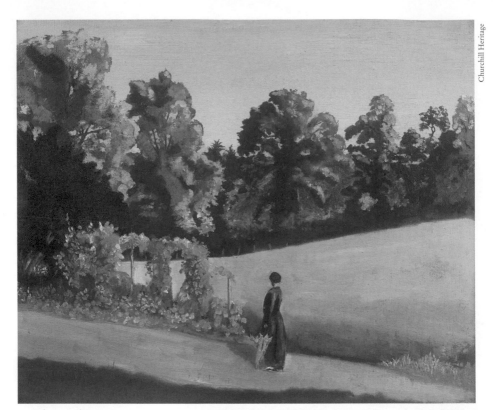

Churchill Heritage

3. The gardens at
Hoe Farm, with Lady
Gwendeline Churchill
in the foreground, 1915.
It was 'Goonie', as
she was known in the
family, who persuaded
her brother-in-law
Winston to take up
painting.

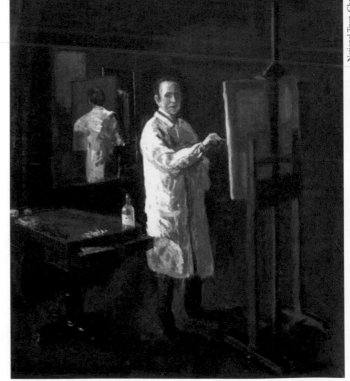

National Trust, Chartwell

4. Sir John Lavery
in his studio, 1915.
Churchill gave this
picture to Lavery in
gratitude for his early
help and advice.

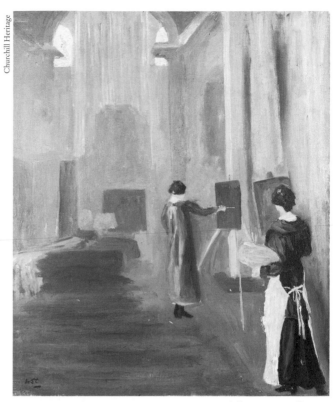

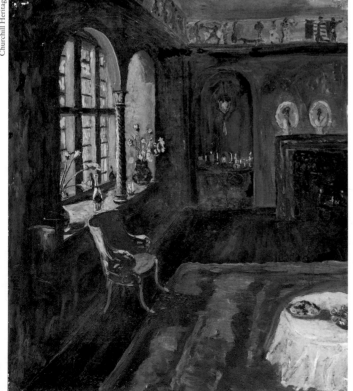

Churchill Heritage

Churchill Heritage

5. The Long Library at Blenheim Palace in 1916, with Sir John Lavery's wife Hazel, and 'Goonie' Churchill both at their easels.

6. The Blue Room at Port Lympne, c. 1921. Owned by Sir Philip Sassoon, Port Lympne was one of many country houses that Churchill loved to visit – and to paint.

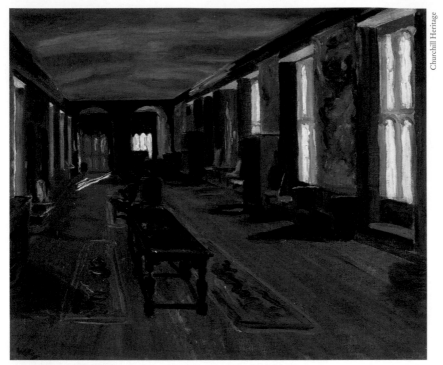

Churchill Heritage

7. The Long Gallery at Sutton Place, 1921. This Tudor mansion was owned by the Duke of Sutherland, and was another favourite subject for Churchill.

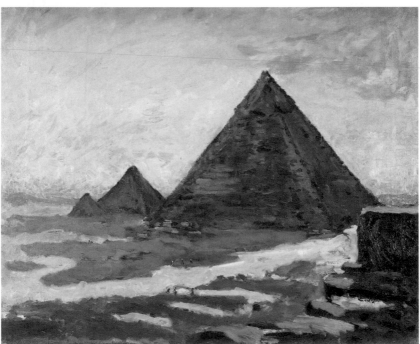

Churchill Heritage

8. The Pyramids, 1921, painted by Churchill when he was in Cairo, presiding over a conference as Colonial Secretary, intended to settle the future of the Middle East.

Churchill Heritage

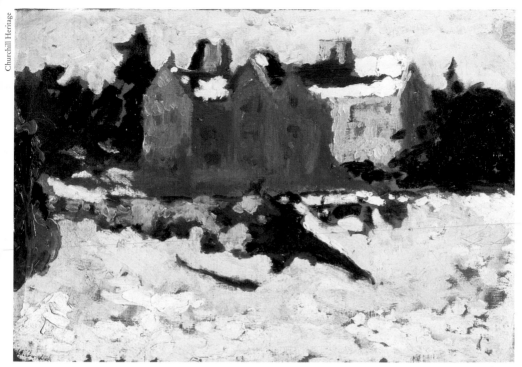

Churchill Heritage

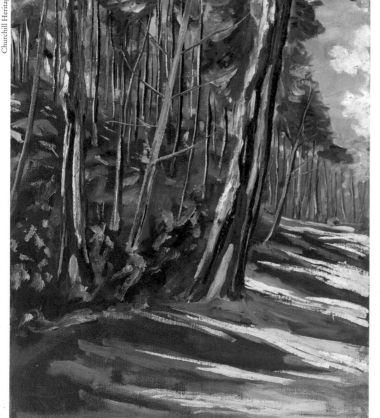

9. Winter Sunshine at Chartwell, c. 1924. This would be one of the pictures entered by Churchill, as 'David Winter', for exhibition at the Royal Academy in 1947.

10. Trees at Mimizan, c. 1925. Mimizan was the French estate of the second Duke of Westminster, where Churchill was a regular visitor during the inter-war years.

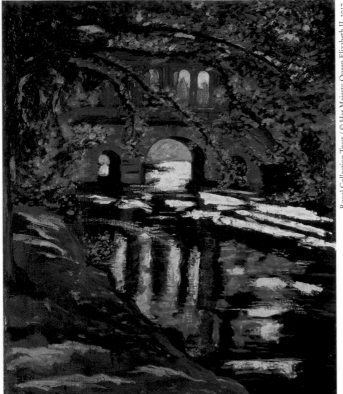

Royal Collection Trust / © Her Majesty Queen Elizabeth II, 2017

11. The Palladian Bridge
at Wilton, 1925. Wilton
was the home of the Earl of
Pembroke, and Churchill
also stayed there frequently.

Churchill Heritage

12. The Great Hall at
Blenheim Palace, c. 1928.
This was one of many
Blenheim interiors that
Churchill painted, and he
gave it to his cousin, the
Duke of Marlborough.

Churchill Heritage

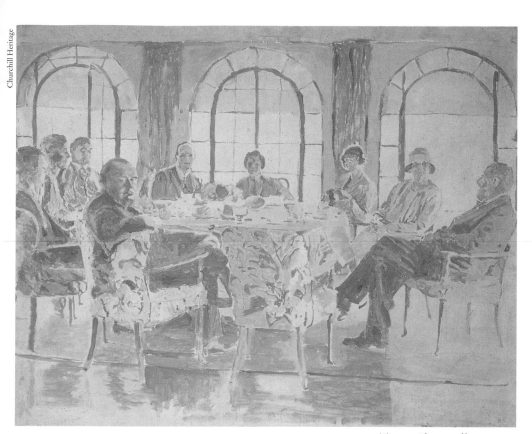

13. Tea at Chartwell, c. 1928. Based on a photograph taken in the dining room at Chartwell by Donald Ferguson in the previous year.

Churchill Heritage

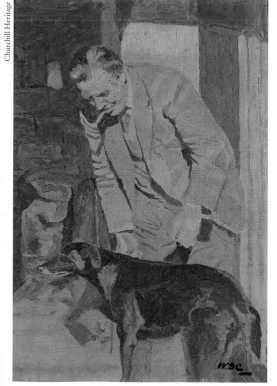

14. The second Duke of Westminster with his lurcher Sam, late 1920s. Another picture that Churchill, influenced by Sickert, painted from a photograph.

Churchill Heritage

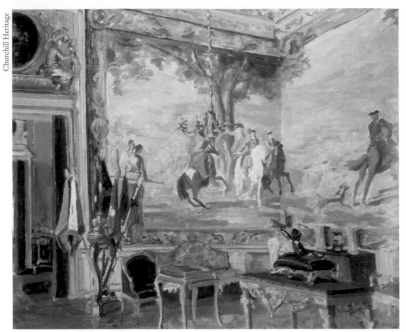

15. Tapestries at Blenheim Palace, c. 1930, commemorating the first Duke of Marlborough's great military victory of 1704.

16. View of Monte Carlo and Monaco, c. 1930. Churchill adored the French Riviera, for its light and warmth, but also because he liked to gamble in the local casinos.

Churchill Heritage

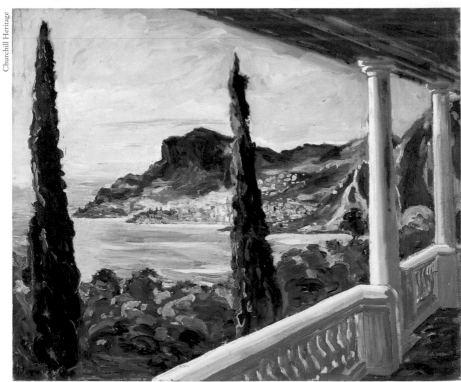

his brushes, and freely admitted that his late-developing artistic talents were limited, being merely those of a 'weekend and holiday amateur'. 'We must not be ambitious,' he insisted. 'We cannot aspire to masterpieces. We may content ourselves with a joy-ride in a paint-box.' But to achieve such outcomes, he urged, 'audacity is the only ticket.'[52] As a former soldier turned painter, he naturally envisaged his encounters with empty, pristine and intimidating canvasses as battles of will, which had to be won by an overwhelming display of forceful colours and colourful force. As he described it in these articles, painting was not just about therapy and recreation: the canvas must be coerced and conquered, subdued and suborned. Churchill also wrote in favourable terms of John Ruskin, and applauded his delight in bright, vivid colours: 'I rejoice with the brilliant ones, and am genuinely sorry for the poor browns.'[53] He was especially appreciative of Turner, the Impressionists and Matisse, and shared their fascination with the effect of light on landscape and water. Throughout his life in art, they would be his models and his inspirations. Painting, Churchill insisted, gave a heightened sense of the natural world, absorbed and stimulated the mind without fatiguing the body, provided a great incentive to travel to far-away places, and furnished a hobby and a distraction which would be a lifelong comfort and companion.

Despite Clementine's concerns, these articles were generally well received, and they were also evidence of Churchill's growing reputation as an amateur artist. By then, he was regularly attending the Royal Academy summer banquets, not only as a government minister (he was in office from 1917–22, and again from 1924–9) but, increasingly, on account of his paintings. At the dinner

held in 1919, Churchill had again concentrated on international affairs, but he also spoke briefly about 'art', in particular the recent 'tragic canvas' by John Singer Sargent, depicting soldiers blinded and wounded by poison gas, and he concluded by hoping that art would 'emerge from this war … revivified and beautified, as it always has been, by tragedy, trial and tribulation'.[54] In 1927, in replying to the toast to 'His Majesty's Government', Churchill spoke on 'Art and Politics', insisting that artists were among 'the most fortunate mortals on the globe', because their work was also their joy. The paintings on display that year, he went on, were the results of 'hours of pleasure, hours of intense creative enjoyment', and the results were what he revealingly described as 'bottled sunshine, captured inspiration, perennial delight'. In comparing art and politics, he continued, 'flair and judgment' were equally necessary in both activities, and there were 'three dominant elements' of both professions that were 'common to both', namely 'colour, proportion and design'. Not surprisingly, Churchill believed that 'colour ranks far above proportion and design both in painting and politics.' 'I admire it very much indeed in painting,' he went on; and, to general amusement, he added: 'I am not entirely averse to it in politics,' although he did also concede that in art, no less than in politics, colour needed disciplining by proportion and design.[55]

By then, Churchill was concentrating most of his artistic efforts on still-lifes, interior and exterior scenes, and landscapes and seascapes. Chartwell remained an obvious subject, and many of his Blenheim canvasses also date from this time [Figs. 12, 15, 24]. Winston and Clementine were

regular visitors to the country mansions of their aristo-
cratic relatives and plutocratic friends: hence Churchill's
paintings of such great houses as Port Lympne, Sutton
Place, Wilton and Cranborne Manor House [Figs. 6, 7,
11, 20].[56] He (but not she) was also increasingly attracted
to the bright sunshine and strong colours of France's
countryside, and its Mediterranean coast, and Churchill
often stayed with the hostess Maxine Elliott, the fabu-
lously rich Duke of Westminster and the press Lords
Rothermere and Beaverbrook [Figs. 10, 21]. An especial
favourite was Consuelo Vanderbilt Balsan, who had been
married to the ninth Duke of Marlborough, but who had
divorced him and married a rich Frenchman [Fig. 23].[57]
Here is Consuelo's account of Churchill as a house guest
and amateur artist:

> He used to spend his mornings dictating to his secre-
> tary and his afternoons painting either in our garden
> or on some other site that pleased him. His departure
> on these expeditions was invariably accompanied by a
> general upheaval of the household. The painting para-
> phernalia, with its easel, parasol and stool, had to be
> assembled; the brushes, freshly cleaned, to be found; the
> canvas chosen, the right hat sorted out, the cigar box
> replenished. At last, driven by our chauffeur, and accom-
> panied by a detective the British government insisted
> upon providing, he would depart with the genial wave
> and rubicund smile we have learned to associate with
> his robust optimism. On his return, he would amuse
> us by repeating the comments of those self-sufficient
> critics who congregate round easels. An old Frenchman

one day told him: 'With a few more lessons, you might become quite good.'[58]

Churchill continued to seek expert artistic advice on into the 1930s, and two more painters became both friendly and influential: Paul Maze and Sir William Nicholson. Maze was a Frenchman who had been a distinguished war artist, with whom Churchill struck up a long and close friendship, contributing a preface to his memoirs, *A Frenchman in Khaki*, in 1934. But Maze also thought Churchill had been 'under the influence of too many people when he began', and dismissed Sir John Lavery as 'slick and superficial'.[59] Sir William Nicholson was an established portrait painter, and also a landscape and a still-life artist, and Churchill would later claim that he was 'the person who taught me most about painting'. Clementine was an especially appreciative admirer, because she believed Nicholson's relatively subdued tones and liking for muted colours softened her husband's exuberant palette. She preferred Winston's 'sparkling sunlit scenes' to be 'cool and pale à la Nicholson' rather than too highly coloured, as she feared was so often the case.[60] Winston and Clementine disagreed about many things during their marriage, and his paintings were no exception. She thought many of them 'over-finished', and she did not share his liking for the Mediterranean coast, preferring high peaks and snow-covered mountains, by which he was never much enthused [Fig. 18]. During late 1935, he discovered the painterly delights of Marrakesh, and stayed at the Mamounia Hotel, which was 'one of the best' he had ever encountered. Churchill loved the warmth, the sunlight, the gardens, the palm trees and the views of the Atlas Mountains, and he

thought the pictures he painted there 'a cut above anything I have ever done so far' [Fig. 22].[61] From the mid-1930s until the late 1950s, Marrakesh would become very special for Churchill, though less so for Clementine.

For most of the 1930s, Churchill was out of office, and with time on his hands he completed his multi-volume biography of the first Duke of Marlborough, and the initial draft of his *History of the English-Speaking Peoples*. He also wrote his essay on 'Cartoons and Cartoonists', met Hollywood actors on his visits to the United States, and was unavailingly involved in writing screenplays for Alexander Korda. In 1932 and 1934, he reviewed two of the Royal Academy summer exhibitions for the *Daily Mail* (though sections of both articles were in fact contributed by Churchill's former private secretary and sometime ghost-writer, Sir Edward Marsh).[62] He gave especial attention to portraits by his friends and teachers, Orpen, Lavery and Sickert, and to the paintings of his fellow politicians, Lord Hugh Cecil, Lord Irwin, Stanley Baldwin and Ramsay MacDonald (though he disliked Dame Laura Knight's depiction of the Duchess of Rutland). He thought there were 'bewilderingly many' landscapes, but in both reviews he gave the work of Alfred Munnings special attention, one painting 'triumphantly gay and summery', another a 'delicate white-and-brown snow-piece'. He also singled out the designs by Sir Edwin Lutyens for what would be his unachieved masterpiece, the Roman Catholic cathedral in Liverpool.[63] He delighted that there was 'an almost complete lack of slovenly or impudent work' on display; and he acclaimed 'the gaiety and love of colour which characterize our art at the present time'. (Was it coincidence that the same description also applied to his

own work?) He also praised the Royal Academy itself, as being 'first and foremost a national institution, like the Poet Laureateship or the Derby', and for providing 'the means by which our country has chosen to acknowledge the existence and the importance of the graphic arts'.[64]

Even during these 'wilderness years' Churchill was still regularly invited to the Royal Academy summer banquets, though as a private citizen and amateur artist, rather than as a politician who was no longer in office, and he spoke on two occasions.[65] In 1932, his subject was 'Political Painters' for, as he self-deprecatingly explained, 'I would not dream of lecturing the Royal Academicians on your art.' Instead, he chose to describe, in a fanciful and light-hearted way, the aesthetic identities of the members of the National Government, from whose ranks he had been excluded. In particular, he spoke of Stanley Baldwin, whose carefully cultivated self-image of rural decency was, he contended, lacking in colour and precise definition, and for whom such bucolic artistic offerings as 'The Worcestershire Farm', 'Pigs in Clover' and 'Broccoli in Autumn' would be appropriate.[66] In 1938, he spoke on 'Tradition and Novelty in Art', a particularly sensitive matter in the Academy, which was increasingly divided between the conservatives and the modernists. Churchill's sympathies were with the former, but he took care to be tactful. 'The function of such an institution as the Royal Academy', he urged, 'is to hold a middle course between tradition and innovation. Without tradition, art is a flock of sheep without a shepherd. Without innovation, it is a corpse.' But innovation, Churchill went on, had its limits: 'it is not the function of the Royal Academy to run wildly after novelty.' Now, more than ever, he believed, it was the purpose of the Academy to

give 'strong, precious and enduring aid' to British painting and sculpture. 'In this hard, material age of brutal force', he concluded, speaking soon after Hitler had annexed Austria, 'we ought indeed to cherish the arts. Ill fares the race which fails to salute the arts with the reverence and delight which are their due.'[67]

Every speech that Churchill made about art, both during and after the inter-war years, was delivered to the Royal Academy, with one conspicuous and revealing exception. In July 1937, at the request of Sir John Lavery, he had spoken at the New Burlington Galleries in London, at the opening of an exhibition devoted to Sea Power in Art, which displayed paintings of Royal Navy ships and the British merchant marine.[68] A few days before, an exhibition entitled *Entartete Kunst* (Degenerate Art) had opened in Munich, the aim of which was to hold up modern art to public ridicule, and at which Hitler had spoken, denouncing all such work as 'Jewish' or 'Bolshevik'. During the same summer, Nazi authorities confiscated some 17,000 works of modernist art from German museums, which had previously been at the forefront in collecting and exhibiting the avant-garde.[69] In his brief remarks at the opening of the Sea Power show, Churchill gave his retort, which anticipated the speech he would make at the Royal Academy in the following year. Hitler's comments, he insisted, 'were very drastic and formidable pronouncements'. Working as an artist in a country with such a leader must be 'a very hazardous employment'. 'If', he went on, 'you had only the alternatives of being hung if your picture were accepted or hanged if it were rejected, it might put a great damper on individual enthusiasm.'[70] Churchill was no great admirer of modern art or abstract

painting, but by the late 1930s he had come to recognize that freedom of artistic expression was essential to any society that cherished liberty, and that Hitler's attacks on art were one further indication of the evils of Nazi tyranny. Ever since he had been a wayward schoolboy, Churchill had fought for individualism against regimentation. Without freedom to paint, he now believed, there could be no freedom to live. Democracies valued artists; dictatorships did not.[71]

III

In the summer of 1939, Churchill completed his final inter-war canvasses in Normandy in the company of Paul Maze. 'This is', he told his friend, 'the last picture we shall paint in peace for a very long time.' When the Second World War began, Churchill returned to office as First Lord of the Admiralty, the same post he had occupied in 1914. While there, he hoped that Sir William Nicholson might be author-ized to paint the Royal Navy at Scapa Flow: 'The lights were very beautiful when I was there last week. Such pictures would be an artistic record.'[72] (Here was the germ of an idea which would eventually result in the War Artists' Advisory Committee, chaired by Kenneth Clark at the Ministry of Information.) In May 1940, Churchill became prime min-ister, and for the duration of the war, defeating the Nazis would be his highest priority. By extraordinary coincidence, Britain and Germany during the Second World War were both led by men who were artists; but whereas Churchill was a successful amateur, Hitler was a failed professional.[73] He had sought to gain admission to the Vienna Academy in 1907, convinced that he had high aesthetic talent. But his work was derivate and unoriginal, and lacked the essential

spark of creativity, let alone the genius that he mistakenly believed he possessed. For a time, he eked out a living producing postcards, but he later abandoned art as a career, and never forgave the Viennese cultural establishment for having snubbed and shunned him. But his teachers had been right.[74] Churchill was not a great artist, but he was a very accomplished painter, whereas Hitler had no talent whatsoever.

From the autumn of 1939 until the summer of 1945, Churchill was a titanically busy man, as affairs of state took all of his waking and working hours, and he gave up his brushes and his canvasses almost completely. But two revealing episodes showed that the war leader was still the artist, and that his verbal and visual imaginations remained vividly conjoined.[75] The first was the powerful painterly image he used to such telling effect in the peroration of his great speech delivered in June 1940, ending, 'This was their finest hour,' in which he contrasted 'the abyss of a new dark age' (the 'black dog' writ large) into which Europe would sink if Hitler triumphed, with the 'broad sunlit uplands' (where 'light would be life') which might be attained if Hitler could be defeated. Those 'broad sunlit uplands' were the vistas Churchill delighted to depict with his paints and his brushes; and they had now become the metaphorical destination to which he hoped to lead his country and its allies.[76] Appropriately enough, the only canvas that Churchill covered while wartime prime minister was of just such an uplifting panorama: a view of Marrakesh, drenched in sunlight, and rising towards the high peaks of the distant Atlas Mountains, which he painted in January 1943 following his meeting with President Roosevelt at Casablanca. After their formal business had been concluded,

Churchill and FDR visited Marrakesh together, and once the President had departed, Churchill set to work with his paints, and he later gave the picture to Roosevelt as a memento of their joint visit. He was 'reluctant to break the illusion of a holiday'; but then it was back to work, and back to battle [Fig. 25].[77]

Just as Churchill had discovered the therapeutic value of painting at the darkest time of his life during the First World War, so he turned to his brushes and canvasses again after his landslide defeat and public rejection at the general election held in the summer of 1945. Even as the votes were being counted, he had headed to the south of France in July for a brief holiday, where he had set up his easel for the first time since Marrakesh. And in September, having faced the new parliament as Leader of the Opposition, he flew to the shores of Lake Como in Italy, where Field Marshal Alexander, the Allied Commander in the Mediterranean, a fellow painter, and a Churchill favourite, offered him his villa.[78] As after the Dardanelles disaster, the therapy worked and, within a month, Churchill produced fifteen pictures. 'I paint all day and every day,' he wrote to his daughter Mary, 'and have banished care and disillusionment to the shades. Alex came and painted too.' 'I am confident', he told Clementine, 'that with a few more months of regular practice, I shall be able to paint far better than I have ever painted before. This new interest is very necessary in my life.' [Fig. 26][79] Thereafter, covering canvasses would once more be Churchill's major relaxation, as he took time off from dictating his war memoirs, from leading the Conservative opposition in parliament, and from making triumphant visits to the United States and to the capital cities of Europe. Once again, he sought light and warmth in France

and Morocco, as 'hotels turned themselves inside out to make Churchill comfortable.' [Figs. 27, 28, 37, 38] They evidently succeeded. 'If it weren't for painting', he told John Rothenstein at just this time, 'I couldn't live. I couldn't bear the strain of things.'[80]

By this stage, Churchill's painting was no longer just a therapeutic exercise and a private hobby: it also became an essential part of his vastly enhanced public reputation, which had taken off in 1940 on both sides of the Atlantic, and which was reinforced rather than diminished, both nationally and globally, by his electoral defeat in 1945. Having led Britain through the Second World War to ultimate victory, and in the aftermath of President Roosevelt's death in April 1945, Churchill had become the most famous and admired figure in the Western world. His multi-volume war memoirs were international bestsellers, and for the remainder of his lifetime and beyond, they were widely regarded as the ultimate and authoritative account of that conflict, and of his heroic part in it. One grateful British sovereign gave Churchill the Order of Merit, another bestowed on him the Order of the Garter. He was already Chancellor of Bristol University, and a Fellow of the Royal Society, and he was subsequently elected an Honorary Fellow of the British Academy. Across Western Europe, cities vied with each other to pay Churchill homage, and on both sides of the Atlantic, universities showered him with honorary degrees. In 1950 *Time* magazine declared him to be the 'man of the half-century', and three years later, Churchill was awarded the Nobel Prize for Literature 'for his mastery of historical and biographical description, as well as for brilliant oratory in defending exalted human values'.[81] In these late years of global fame,

it did, indeed, seem to many (though not to everyone) as though there was nothing that Churchill could not do, and no honour that he did not deserve [Fig. 40].

Churchill's artistic endeavours were an essential part of this post-war acclaim and late-life apotheosis, as they became much more widely known and admired. In January 1946, *Life* magazine, the American picture weekly, ran a story on 'The Paintings of Winston Churchill', and in July and August the *Strand* magazine reproduced seventeen of his pictures, and reprinted extracts from his two essays they had earlier published.[82] More importantly, it was during these years that Churchill's relationship with the Royal Academy moved into a much higher gear. This was largely thanks to the initiatives of its President, Sir Alfred Munnings, who had succeeded Sir Edwin Lutyens in 1944. Munnings was a famous painter of conventional sporting scenes, especially fox hunting and horse racing, which he often produced for rich aristocratic and plutocratic clients, and he was notorious for his visceral and vituperative hostility to modern, non-representational art. He was also a friend of Churchill's, and they often saw each other at dinners of the Other Club. In 1947, Munnings revived the Royal Academy Summer Exhibition, which had not been held during the war years, and encouraged Churchill to submit two pictures for consideration, which he did under the pseudonym of David Winter.[83] Both works were accepted, the real identity of the artist was only then revealed, and they were duly put on display, the first time that any British prime minister had exhibited at the Academy. But this was only the beginning, for in 1948, Churchill was elected an Honorary Academician Extraordinary, by the unanimous resolution passed by both

the Academy's Council and its General Assembly [Fig. 39].
No amateur artist had been so recognized before, and none
has been so honoured since.[84]

In the same year, and at the initiative of Odhams publish-
ers, Churchill's two early articles on art that had already been
reprinted in his book of essays, *Thoughts and Adventures* (1932),
were adapted and again republished as *Painting as a Pastime*,
which was illustrated with colour reproductions of many of
his pictures.[85] The book reached the shops in early December,
just in time for the Christmas market, and sold more than
50,000 copies. It was an ideal stocking-filler, providing a wel-
come distraction from the post-war gloom of austerity Britain,
and many readers, encouraged by Churchill, would take up
painting having read him. The book was also well received
by the critics, many of whom had been unaware of Churchill's
other life as an artist, and they delighted in its warm and self-
deprecating tone, which was in marked contrast to the son-
orous rhetoric of his history of the Second World War, the
first volume of which had appeared earlier in the same year.[86]
Painting as a Pastime also sold more than 25,000 copies in the
United States, where it was published in January 1950. The
reviews were again favourable, that by Eric Newton in the
New York Times being a good example, and Eugene Warner,
the Vice-President and General Manager of McGraw Hill,
took up painting as a result of reading it. The book was trans-
lated into many foreign languages, including French, German,
Dutch, Finnish and Japanese, and it did much to establish
Churchill's reputation as 'the world's most celebrated ama-
teur painter'. Thereafter, Churchill's 'daubs' were no longer
just a private hobby and personal therapy, but became an
essential aspect of his global fame as an heroic figure and as

a multi-talented man. In 1949, Clementine persuaded him to donate one of his paintings for an auction in aid of the Young Women's Christian Association. It was bought for £1,312 by a Brazilian who presented it to the Art Museum in Sao Paulo.[87]

At the same time, and with Churchill's active prompting and support, Munnings revived the Royal Academy banquet after a lapse of ten years. Churchill was naturally invited, and made a few brief remarks after the dinner, but Munnings delivered an uninhibited and intoxicated speech, broadcast live by the BBC on the wireless, in which he denounced the Academy itself, along with the Arts Council and the Tate Gallery, for their misguided embrace of modern art, inveighed against such 'foolish daubers' as Cézanne, Matisse and Picasso, and insisted that Churchill shared these views. He may have done, but he admired Cézanne and Matisse, and he believed strongly in freedom of artistic expression, and he subsequently rebuked Munnings for revealing and misrepresenting a private conversation. The outrage and embarrassment caused by his remarks was so great that Munnings was compelled to resign the Presidency.[88] By contrast, Churchill's relations with the Royal Academy continued to be close and cordial, and he exhibited at every Summer Exhibition between 1948 and 1951. Just as his association with the Academy added to his own lustre and renown, so the Academy's association with him enhanced its own standing and significance, and Churchill got on well with Munnings's three Presidential successors, Sir Gerald Kelly, Sir Albert Richardson and Sir Charles Wheeler (though he would take exception to the portrait of himself by Ruskin Spear which was displayed at the summer exhibition in 1957).[89] They were more tactful than Munnings, but they were all artists

who worked in traditional idioms: Kelly was one of the royal family's favourite portrait painters; Richardson was an architect who preferred a stripped-down, neo-classical style; and Wheeler was a sculptor who had worked with Herbert Baker on the Bank of England, Rhodes House in Oxford and South Africa House on Trafalgar Square.

In 1951, Churchill returned to Downing Street, and by agreeable coincidence presided over an administration containing more painters and men sympathetic to art than any other of modern times. In addition to himself, there was R. A. Butler (Chancellor of the Exchequer), Field Marshal Lord Alexander (Minister of Defence) and Patrick Buchan-Hepburn (Government Chief Whip and Parliamentary Secretary to the Treasury). Moreover, Anthony Eden, the Foreign Secretary, and Churchill's heir-apparent, had inherited a serious interest in art from his father, who had been a talented water-colourist and collector of impressionists. At different times, both Butler and Alexander painted alongside Churchill, dividing up the landscape between them; but while they were admiring of his artistic talents, they were also critical. Butler believed that his own paintings were 'no worse' than the Prime Minister's, and claimed that he 'did not think so either'. He thought Churchill's best pictures were painted at Chartwell, but that those he completed of the Italian lakes, 'with blue water and green trees', were the least successful. He also noted that there was 'little intellectual content' in Churchill's paintings, but recognized they provided him with 'complete recreation' rather than push the boundaries of artistic expression and innovation.[90] Alexander, who had originally intended to be an artist, later exhibited at the Royal Academy, and had cherished youthful ambitions to be

its President, was also critical. Despite the best efforts of Clementine and Sir William Nicholson, he believed that Churchill 'used far too many [colours]. That's why his paintings are so crude. He couldn't resist using all the colours on his palette.' (Sarah Churchill, by contrast, thought that Alexander's own style was very similar to her father's).[91]

Churchill's second and final premiership lasted until the spring of 1955, but the continued press of events, combined with his own advancing years and increasing ill-health, meant that he once again had little time for painting. He covered a few canvasses on his occasional sojourns at La Capponcina, Lord Beaverbrook's Mediterranean villa, and also on a brief trip to Jamaica in the aftermath of a visit to the American President when, perhaps remembering the earlier decision he had made at Hoe Farm, he reminded Noel Coward 'firmly but kindly about painting in oils instead of dabbing away at watercolours' [Fig. 29].[92] He exhibited every year at the Royal Academy summer show: as Prime Minister and the only Honorary Academician Extraordinary, it was inconceivable that his canvasses would have been turned down, and he was advised by Gerald Kelly and Kenneth Clark as to which pictures to submit.[93] Churchill was also a regular attendee and speaker at the Academy annual banquet, where he continued to urge the need to 'hold a middle course between tradition and innovation'. In 1953, recycling his remarks from fifteen years before, he insisted that 'the arts are essential to any complete national life' and that 'the nation owes it to itself to sustain and encourage them'.[94] Twelve months later, he was brooding on the terrible perils that might be unleashed by the recently-detonated hydrogen bomb and, in what would be his last Academy speech, he

urged that 'the arts have a noble and vital part to play' in helping mankind deal with these 'gigantic powers which confront us with problems never known before'.[95]

During these late prime ministerial years, two anthologies were published, coinciding with Queen Elizabeth II's coronation in 1953 and his own eightieth birthday in November the following year, celebrating Churchill's many achievements and varied accomplishments, and both contained essays describing and assessing him as an artist. The first was by Thomas Bodkin, who had been Director of the National Gallery of Ireland and subsequently Barber Professor of Fine Arts and Director of the Barber Institute at the University of Birmingham. Bodkin regarded Churchill as 'the most remarkable Englishman who has ever lived', gently pointed out some of his artistic deficiencies, and noted his preference for landscapes and scenes of 'light and peace'. Churchill, he concluded, was an 'instinctive painter': he might not be a 'Master', but he was unquestionably an 'Artist'.[96] The second tribute was by Sir John Rothenstein, who was Director of the Tate Gallery.[97] Like Bodkin, Rothenstein thought Churchill was 'the greatest man of the age', and perceptively but tactfully observed that by the 'skilful choice of subjects within his range', he was 'able to paint pictures that convey and enhance delight and are distinguished by their painterly qualities [and] that have an intimate and direct relation to his outlook on life'.[98] More critically, Rothenstein noted that Churchill's 'gay, brilliantly coloured canvasses' stood in stark contrast to the 'struggle or tragedy' of public affairs, with which for most of his political life he was 'profoundly and consistently preoccupied'. 'Had he dedicated an entire laborious lifetime to

the tempering of his powers', Rothenstein went on, 'and to the disciplining of his visual imagination', he would have 'been equipped to express a large part of himself, instead of a few facets'. But 'he was a late starter; he had neither the systematic training nor the leisure necessary to develop his talents to the full.' The 'long daily experience of painting', culminating in technical mastery, was not for him.[99] Yet Rothenstein was also eager to obtain a Churchill canvas for the Tate, although he would wait until he had left 10 Downing Street for the last time, because he wanted the painting 'for artistic and not political reasons'.[100]

IV

Churchill had finally retired as prime minister in the spring of 1955, and his political life was effectively over. Freed for the last time from the cares and burdens of high office, his final decade would be one of public acclaim, private leisure and growing infirmity. But as he had earlier foreseen, in the articles that eventually became *Painting as a Pastime*, his brushes and his canvasses would play a significant part in these last years – very nearly, but not quite the whole way, to the close of his life

> One by one, the more vigorous sports and exacting games fall away. Exceptional exertions are purchased only by a more pronounced and more prolonged fatigue. Muscles may relax, and feet and hands slow down; the nerve of youth and manhood may become less trusty. But painting is a friend who makes no undue demands, excites to no exhausting pursuits, keeps faithful pace even with feeble steps, and holds her canvas as a screen

36

between us and the envious eyes of Time or the surly advance of Decrepitude. Happy are the painters, for they shall not be lonely. Light and colour, peace and hope, will keep company to the end, or almost to the end, of the day.[101]

Immediately following his retirement, Churchill departed for a holiday in Sicily, where he again re-discovered his pleasure in painting, and did so with 'considerable vigour' for three hours at a stretch. During the late 1950s, he spent a great deal of time on the French Riviera, escaping the cold and damp English winters, which he 'hated', relishing the 'light and colour' of the Mediterranean, and staying with Lord Beaverbrook at La Capponcina, or with his new friends Emery and Wendy Reeves (to whom Clementine took a great dislike) at their villa, La Pausa [Figs. 31, 41]. In such luxurious surroundings, and with such congenial company, Churchill completed his *History of the English-Speaking Peoples* ('the language', Emery Reeves noted, 'sometimes evokes great paintings'); but he found spending long hours at the easel increasingly tiring, and he rarely felt 'up to it', either physically or mentally. On his final visit to Marrakesh in 1959, he produced 'but two pictures in five weeks' [Fig. 32].[102]

Churchill's last decade, from 1955 to 1965, was not only one of political inactivity and increased frailty, but also a time of extraordinary public apotheosis, of which he himself seems scarcely to have been aware, but in which his pictures played an increasingly prominent part. Urged on by his former colleague and fellow soldier-painter President Eisenhower, the Nelson Art Gallery in Kansas

City displayed thirty of Churchill's canvasses in January 1958, and the president wrote the foreword to the exhibition catalogue.[103] The show was a record-breaking success, and received strong, bi-partisan political support. 'Damn well done!', Eisenhower's predecessor, Harry S. Truman, declared. 'You can at least tell what he painted, and that is more than you can say about many of these modern painters.' After drawing unprecedented numbers in Kansas City, the pictures were exhibited widely across the United States, including the Smithsonian in Washington and the Metropolitan Museum of Art in New York. (The art museums in Pittsburgh, Cincinnati and Chicago all refused, on the grounds that Churchill's works were of insufficient merit or originality; but in Chicago there was a huge public outcry, and the director of the Art Institute resigned soon after.[104]) From the United States, Churchill's paintings travelled on to Toronto, Montreal, Vancouver and Fredericton in Canada, to seven cities in Australia, and to four in New Zealand, and in each country there was great public interest and strong prime ministerial support. In Canada, John Diefenbaker contributed the foreword to the catalogue; in Australia, Robert Menzies did the same; and in New Zealand, Walter Nash opened the exhibition in Wellington. As Churchill rightly observed, thanking Eisenhower for his support of the original Kansas display, from which so much had followed, 'You have gained for me a worldwide reputation as a painter.'[105]

Churchill had previously resisted all suggestions that the Royal Academy should mount an exhibition devoted exclusively to his work, insisting that he did not 'contemplate such a display in my lifetime'. But following his retirement

as prime minister, the requests were renewed. He might not be a professional painter, but he was an Honorary Academician Extraordinary, 'and is not everything about him Extraordinary?', asked Gertrude Jeans of Sir Gerald Kelly. 'Come to that', she added, 'he is not a professional saviour of civilization either, yet he is freely acknowledged as such the world over.' Initially Churchill continued to refuse, but the successful displays of his pictures in north America and the Antipodes emboldened the Academy to ask again. This time, Churchill agreed, and Augustus John was invited to contribute the preface to the exhibition catalogue.[106] In his draft he recalled his first encounter with Churchill, who had only recently taken up painting, in Lavery's studio. 'Much as I appreciated the vigour and dash of the oil sketches', he recalled, 'I failed to discover any sign of that patient attention to detail and the structure and proportions of form, which, when a student at the Slade, I had learned to look for, and find, in the earliest studies of the masters.' As a result, John remembered, he urged on Churchill 'more caution, stricter self-control and a closer observance of "tradition"', instead of encouraging him 'to proceed with even greater audacity, freedom and independence of spirit'. In retrospect, this had clearly been a mistake, and John went on to describe some of their later encounters, including an abortive scheme to undertake his portrait, and one later, memorable lunch at Chartwell.[107] But although of undoubted interest, John's reminiscences were deemed 'inadequate and diffuse', and consigned to the Royal Academy's archives. Instead, Sir Charles Wheeler produced a 'more restrained, dignified and appropriate' introduction.[108]

The Academy's display of Churchill's pictures was much larger than the recent overseas touring shows, and after a private viewing to which Churchill's extended family and many of his political friends and colleagues were invited, the exhibition opened in March 1959. It was a 'phenomenal success', with 3,210 visitors on its opening day – a record for a one-man show. The queues stretched all along Piccadilly, and so great was the demand that its run was extended from the end of May to the end of July, by which time over 140,000 people had visited – a greater number for any exhibition held in the same spaces of Burlington House except one devoted to the work of Leonardo da Vinci. The critics were also friendly.[109] Two of them treated the exhibition at some length. In *Country Life*, Christopher Hussey noted that 'The Diploma Gallery at Burlington House has certainly never before contained an exhibition by so great a man as Sir Winston Churchill or more joyous paintings than the three score that now fill two of its rooms.' In the *Birmingham Post*, Thomas Bodkin, now taking a more critical line, argued that on the grounds of artistic accomplishment alone, Churchill would not merit the title Honorary Academician Extraordinary. But, he went on, somewhat self-contradictorily, 'judged by any fair test, he has to be regarded as a serious and accomplished painter who has won, on his merits, the right to take his place amongst the ranks of his professional colleagues.'[110] 'We think', Sir Charles Wheeler wrote to Churchill when the show closed, 'it has deservedly marked in the most effective and significant way your historic membership of the Royal Academy, thus crowning your "Extraordinary" title in our annals.' There were requests that the exhibition should travel on to Manchester, Cardiff,

Belfast, Glasgow and Edinburgh, but Churchill wanted 'the pictures back after their long absence'.[111]

By then, he was visibly ageing, as the 'surly advance of decrepitude' was becoming irresistible, and as 'the end of the day' drew inexorably closer. Churchill painted his last canvasses at Lord Beaverbrook's villa in 1960, and there was a final Chartwell picture, of the goldfish pool, two years later; but the optimism, the sunshine and the vigour that had for so long given his works their warmth and spirit had largely disappeared. 'Colour', he had told his doctor thirteen years earlier, 'plays a great part in life'; but by now the brightness was departing, the 'black dog' could no longer be kept at bay, and Clementine lamented that he was often 'profoundly depressed'. As at the very beginning of Churchill's painterly life, his last pictures expressed his melancholy rather than helped him to overcome it.[112] But he continued to submit earlier works to the Royal Academy, and at the summer banquet in 1959, the Prime Minister, Harold Macmillan, acclaimed Churchill as 'the greatest living amateur painter'.[113] Two years later, Harold Nicolson, who was a lifelong admirer, attended the same event, and recorded this sadly affectionate entry in his diary:

> I watched Winston leaving. The President took one arm, and an attendant another, and they almost carried the old boy down the steps. He is frightfully old. His eyes are bleary and immobile. I watched his huge bald head descending the staircase, and I blessed it as it disappeared. 'We may never see that again,' said a voice behind me. It was Attlee.[114]

Churchill attended the Academy's summer banquet until 1963, and he was accompanied by his bodyguard, Sergeant Murray, who was himself a talented amateur artist [Fig. 42]. Paintings were submitted on his behalf until the last year of his life, by which time Churchill had contributed more than fifty works to the annual exhibitions. His death in January 1965 severed a connection with the Royal Academy extending back to 1908, and with the British art world across more than forty years. As Sir John Rothenstein lamented: 'A great presiding presence was no longer there.'[115]

Churchill's father, Lord Randolph, had died in middle age, he had not expected his own life to be long, he had often witnessed the carnage and killing of war, and he had frequently brooded on the transience of life and the mysteries of death. 'The span of mortals', he wrote in his biography of the first Duke of Marlborough, 'is short, their end universal … It is foolish to waste lamentation upon the closing phases of human life. Noble spirits yield themselves willingly to the successively falling shades, which carry them to a better world, or to oblivion.' But which, for Churchill, was it to be? In truth, he never could quite make up his mind 'about a future life after death'.[116] Having long been a religious sceptic, he often thought that death would, indeed, be the end, a sort of perpetual nothingness, to which he gave the name 'black velvet'. As someone who had never liked dark colours, especially the 'sombre, sepulchral finality of black', and who had spent all his life battling the 'black dog' of debilitating depression, Churchill can hardly have been enthused by such a prospect.[117] But in *Painting as a Pastime*, he set out an alternative vision of the next world which was much more buoyant and optimistic.

'When I get to heaven', he wrote there, 'I mean to spend a considerable portion of my first million years in painting, and so get to the bottom of the subject,' assisted and enabled by 'a still gayer palette than I get here below,' and 'by a whole range of wonderful new colours which will delight the celestial eye'.[118] And as Churchill lay on his deathbed, immobile and apparently insensible, his daughter Sarah claimed that his right hand was seen to move, as if already grasping for the heavenly paintbrush that might yet await him.[119]

There may, or may not, be an afterlife for Churchill himself; but there has certainly been one for his paintings, which constitute one of his most tangible, abiding and accessible legacies. Many still hang on the walls at Chartwell, both in the house and in what became his studio, or remain in the possession of his descendants.[120] During his lifetime, Churchill also gave away approximately a hundred of his pictures, to friends and colleagues on both sides of the Atlantic, including Presidents Roosevelt, Truman and Eisenhower, General Smuts, General Marshall, Sir Robert Menzies, Sir Anthony Eden, Lord Beaverbrook and Lord Montgomery.[121] Today, his paintings may also be found hanging in museums and private collections around the world, from Buckingham Palace to Brunei. In 1959 Lord Beaverbrook had offered 'a hundred and fifty thousand down' for all of Churchill's pictures, claiming that 'when you're gone, they won't be worth two shillings apiece.'[122] But Beaverbrook was wrong: since 1965, the prices for Churchill art have soared not slumped. When fifteen of his canvases were sold in December 2014, following the death of his daughter, Mary Soames, most went for more than half a million pounds, and two of them,

appropriately of Chartwell and Blenheim, fetched well above
£1 million each.[123] For many good reasons, Churchill's
paintings get far greater sums in the salerooms than Hitler's,
and they are much more avidly collected. Since his death,
Churchill's art has often been exhibited: in the United
States, where there have been shows in Washington DC,
New York City, Albany, Dallas, Atlanta, and at the Roosevelt,
Eisenhower, Ford and Reagan Presidential Libraries; and it
has also been displayed in London (several times), as well as
in Tokyo and Stockholm.[124]

<p style="text-align:center">V</p>

The following pages reprint all of Churchill's speeches and
writings on art, as well as reproducing many of his paintings.
The early addresses to the Royal Academy, dating back to
before the First World War, are of interest because, while he
had a great deal to say about politics, government and inter-
national affairs, he had nothing to say about art, and clearly
never expected that he would. During the 1920s and 1930s,
Churchill mingled politics and art much more evenly in his
speeches, for by then he appeared at the annual Academy
banquets in his dual identity as a statesman and as a painter.
His two reviews for the *Daily Mail* of the Academy's Summer
Exhibitions of 1932 and 1934 are also reprinted here, as is
the speech he delivered on art, sea power and freedom at the
New Burlington Galleries in 1937. So, too, is *Painting as a
Pastime*, along with a review by Eric Newton, as well as the
appreciations of Churchill as an artist by Professor Thomas
Bodkin and by Sir John Rothenstein which appeared in the
early 1950s. The anthology ends by printing the hitherto
unpublished preface that Augustus John wrote for the Royal

Academy exhibition catalogue of Churchill's paintings, along with a review of the show by Professor Bodkin, and Sir John Rothenstein's later thoughts. Together with his own speeches and writings, these essays and reviews provide the fullest picture yet of Churchill the painter, both as he saw himself, and as others saw him, too. He may not have been a great artist but, without painting, he might never have been the great man he eventually became. And of all the national institutions with which he was connected in his later years of fame and glory, among them the University of Bristol as Chancellor, the Cinque Ports as Lord Warden, Trinity House as an Elder Brother, and Churchill College, Cambridge, as founder, his connection with the Royal Academy was longer and deeper than with any other except one: the House of Commons itself.

NOTES

The following abbreviations have been used throughout the notes:

AIC Art Institute of Chicago Archives, Art Institute, Chicago
CHAR Churchill papers pre-1945, Churchill Archives Centre, Churchill College, Cambridge
CHUR Churchill papers post-1945, Churchill Archives Centre, Churchill College, Cambridge
RAA Royal Academy Archives, Burlington House, Piccadilly, London
SFT Mary Soames (ed.), *Speaking for Themselves: The Personal Letters of Winston and Clementine Churchill.* London: Doubleday, 1998.
WSC Winston Churchill

1 Lord Moran (1966), *Churchill: The Struggle for Survival, 1940-1965.* London: Constable, p. 298.
2 Jenkins, R. (2001), *Churchill.* London: Macmillan, p. 912; Cannadine, D. (2016), *Heroic Chancellor: Winston Churchill and*

the University of Bristol, 1929–65. London: Institute of Historical Research, p. 74.

3 Berlin, I. (1949), Mr Churchill in 1940. London: John Murray, p. 39.

4 Soames, M. (1990), *Winston Churchill: His Life as a Painter*. London: William Collins; Coombs, D. and Churchill, M. (2003), *Sir Winston Churchill: His Life and His Paintings*. London: Unicorn Press. See also Alberigi, M. L. (1997), 'Sir Winston Churchill as a Painter: The Artist and His Critics' (Sonoma State University: unpublished MA dissertation).

5 Plumb, J. H. (1969), 'The Historian', in A. J. P. Taylor *et al*, *Churchill: Four Faces and the Man*. Harmondsworth: Penguin, pp. 119-21.

6 Stourton, J. and Sebag-Montefiore, C. (2012), *The British as Art Collectors: From the Tudors to the Present*. London: Scala Publishers, pp. 105-6.

7 Cannadine, D. (1990), *The Decline and Fall of the British Aristocracy*. London: Yale University Press, pp. xi-xii, 113; *New York Times*, 25 July 1886.

8 Ormond, R. and Kilmurray, E. (2003), *John Singer Sargent: The Later Portraits*. London: Yale University Press, pp.144–47; Balsan, C. V. (1953), *The Glitter and the Gold*. London: Heinemann, p. 146.

9 Moran, *The Struggle for Survival*, p. 419.

10 Below p. 63.

11 WSC, (1989 edition), *My Early Life: A Roving Commission*. London: Leo Cooper, pp. 17, 37, 52, 130.

12 WSC, *My Early Life*, pp. 123-7.

13 Below pp. 98-100; Cannadine, *Heroic Chancellor*, p. 11; Beloff, M. (1993), 'Churchill and Europe', in Blake, R., and Louis, W. R. (eds), *Churchill*. Oxford: Oxford University Press, p. 454; Plumb, 'The Historian', p. 127.

14 Montague Brown, A. (1995), *Long Sunset: Memoirs of Winston Churchill's Last Private Secretary*. London: Cassell, p. 217; Moran, *Struggle for Survival*, p. 262.

15 Cannadine, *Heroic Chancellor*, pp. 8-11; Addison, P. (2005), *Churchill: The Unexpected Hero*. Oxford: Oxford University Press, p. 14; Rose, J. (2014), *The Literary Churchill: Author, Reader, Actor*. London: Yale University Press, pp. 19-33.

16 Moran, *Struggle for Survival*, pp. 704, 723; Alkon, P. A. (2006), *Winston Churchill's Imagination*. Lewisburg, PA: Bucknell University Press, p. 1; Stourton, J. (2016), *Kenneth Clark: Life, Art and Civilisation*. London: William Collins, p. 162.

17 Rose, *Literary Churchill*, pp. 1-18, 82-94; Walsh, J. J. (1998), 'Postgraduate Technological Education in Britain: Events Leading Up to the Establishment of Churchill College, Cambridge, 1950-58', *Minerva*, xxxvi, pp. 147-77; Carpenter, P. (1985) 'Churchill and His "Technological" College', *Journal of Educational Administration and History*, xvii, pp. 69-75.

18 Moran, *Struggle for Survival*, pp. 65, 302, 422, 425, 440, 737, 770; Graebner, W. (1965), *My Dear Mister Churchill*. London: Michael Joseph, p. 26.

19 Gilbert, M. (2011), *Winston Churchill and the Other Club*. London: privately printed, pp. 38, 70-71, 73-74, 95, 124; Rose, *Literary Churchill*, p. 182.

20 Rowse, A. L. (1971 edition), *The Later Churchills*. Harmondsworth: Penguin, pp. 4, 536; Rose, *Literary Churchill*, pp. 352-3; Moran, *Struggle for Survival*, pp. xvi, 100, 530, 777.

21 Churchill, J. S. (1961), *Crowded Canvas*. London: Odhams Press, pp. 127-41, 253-60.

22 Sheridan, C. (1928), *Naked Truth*. New York: Harper & Brothers, pp. 142-7.

23 Montague Brown, *Long Sunset*, p. 222; See the illustrations in Churchill, S. (1967), *A Thread in the Tapestry*. London: André Deutsch, opposite pp. 32, 80.

24 Cannadine, D. (2002), *In Churchill's Shadow: Confronting the Past in Modern Britain*. London: Penguin Press, pp. 91-2.

25 Berlin, *Mr Churchill in 1940*, pp. 9-10, 12-3, 17-9, 24-5, 28-9, 39; below pp. 106-7.

26 Gilbert, M. (1994), *In Search of Churchill: A Historian's Journey*. London: HarperCollins, p. 67.

27 Rose, *Literary Churchill*, p. 171.

28 WSC, 'Cartoons and Cartoonists', *Strand* magazine, June 1931; reprinted in *Thoughts and Adventures* (1932). London: Thornton Butterworth, pp 23-35.

29 Drazin, C. (2011), *Korda: Britain's Movie Mogul*. London: I. B. Tauris, pp. 108-9, 112-8; Barr, C. (2011), 'Much Pleasure

and Relaxation in These Hard Times: Churchill and Cinema in the Second World War', *Historical Journal of Film, Radio and Television*, xxxi, pp. 661-86; Rose, *Literary Churchill*, pp. 354-5; Churchill, *Crowded Canvas*, p. 133; Churchill, *Thread in the Tapestry*, pp. 35-6; Alkon, *Churchill's Imagination*, pp. 41-95.

30 Rose, *Literary Churchill*, pp. 48-9.

31 Quoted in Alkon, *Churchill's Imagination*, p. 145.

32 Moran, *Struggle for Survival*, p. 320.

33 Wilson, A. (1972), *A Dictionary of British Military Painters*. Leigh-on-Sea: F. Lewis; Stearn, R. T. (1986), 'War and the Media in the Nineteenth Century: Victorian Military Artists and the Image of War, 1890-1914', *Journal of Defence Studies*, no. 131, pp. 55-62; Burant, J. (1988), 'The Military Artist and the Documentary Art Record', *Archivaria*, 26, pp. 33-51; Colley, L. (2004), *Captives: Britain, Empire and the World, 1600-1850*. New York: Anchor Books, pp. 181-3.

34 Gilbert, M. (1990 edition), *Winston S. Churchill*, vol. iv, *World in Torment*, 1917-22. London: Heinemann, pp. 384-6; *SFT*, pp. 222-3

35 Beckett, W. (2006), 'President Eisenhower: Painter', *White House History: Journal of the White House Historical Association*, no. 21, pp. 30-40; Boyle, P. G. (1990, ed.), *The Churchill–Eisenhower Correspondence, 1953-55*. Chapel Hill, NC: University of North Carolina Press, pp. 182-9; Warner, P. (1981), *Auchinleck: The Lonely Soldier*. London: Buchan & Enright, pp. 229-30; Nicolson, N. (1976), *Alex: The Life of Field Marshal Earl Alexander of Tunis*. London: Pan Books, pp. 30, 38, 105, 149-52; Seago, E. (1973), *The Paintings of Earl Alexander of Tunis*. London: Collins.

36 Blanning, T. (2015), *Frederick the Great: King of Prussia*. London: Allen Lane, p. 30; Bush, G. W. (2017), *Portraits of Courage: A Commander-in-Chief's Tribute to American Warriors*. New York: Crown Publishers.

37 Moran, *Struggle for Survival*, pp. 167, 181-2, 310, 745-6, 779, 788; Storr, A., 'The Man', in Taylor *et al*, *Churchill*, pp. 207-9, 215-9, 238-9; Attenborough, W. (2014), *Churchill and the 'Black Dog' of Depression: Reassessing the Biographical Evidence of Psychological Disorder*. Basingstoke: Palgrave Macmillan.

38 Moran, *Struggle for Survival*, p. 745; Black, J. (2017), *Winston Churchill in British Art, 1900 to the Present Day: The Titan with Many Faces*. London: Bloomsbury, pp. 42-4.

39 Gilbert, *In Search of Churchill*, pp. 66-7; Churchill, *Crowded Canvas*, p. 31. For WSC's own account see below pp. 103-4.

40 Gilbert, *In Search of Churchill*, p. 69; Buczacki, S. (2007), *Churchill and Chartwell: The Untold Story of Churchill's Houses and Gardens*. London: Frances Lincoln, pp. 61-3.

41 Rose, *Literary Churchill*, p. 139; *SFT*, p. 179.

42 Buczacki, *Churchill and Chartwell*, p. 125.

43 *SFT*, pp. 179, 655; Gilbert, *In Search of Churchill*, pp. 69-70; Soames, *Churchill: His Life as a Painter*, pp. 42-43; CHAR 1/165: John Lavery to WSC, 15 January 1923; WSC to John Lavery, 29 January 1923.

44 Baron, W. (2006), *Sickert: Paintings and Drawings*. London: Yale University Press, pp. 140, 519-20; Black, *Churchill in British Art*, pp. 73-6; Soames, *Churchill: His Life as a Painter*, pp. 60-72; *SFT*, p. 309; CHAR 1/194, WSC to Richard [sic] Sickert, 30 October 1927.

45 *SFT*, pp. 227, 232, 367.

46 Gilbert, *Other Club*, pp. 93, 96-7, 108, 124.

47 Stourton, *Kenneth Clark*, pp. 108, 119, 158, 161-3, 188-9, 305, 309; Clark, K. (1977), *The Other Half: A Self-Portrait*. London: John Murray, p. 128.

48 Below p. 114; Clarke, P. (2012), *Mr Churchill's Profession: Statesman, Orator, Writer*. London: Bloomsbury, p. xvii.

49 Bonham Carter, V. (1967), *Winston Churchill as I Knew Him*. London: Pan Books, p. 494.

50 Soames, *Churchill: His Life as a Painter*, pp. 57-8.

51 *SFT*, pp. 225, 227-9.

52 Below p. 103.

53 Below p. 111.

54 Below pp. 67-8.

55 Below pp. 70-1.

56 Rose, *Literary Churchill*, p. 182.

57 *SFT*, pp. 246, 261, 360, 415, 417.

58 Balsan, *Glitter and the Gold*, p. 217.

59 Gilbert, *In Search of Churchill*, p. 76; CHAR 8/499: WSC, Draft Introduction, 22 August 1934.

60 *SFT*, pp. 360, 657, 659.

61 *SFT*, pp. 404, 410, 425-7.

62 Coombs and Churchill, *Life and Paintings*, pp. 142-3, 148-9.

63 Below pp. 78-81, 85-7.

64 Below pp. 81-3.

65 Rose, *Literary Churchill*, p. 225.

66 Gilbert, *In Search of Churchill*, pp. 72–74; below pp. 73-4.

67 Below pp. 93-4.

68 CHAR 1/302: Sir John Lavery to WSC, 20 February 1937, 30 April 1937, 29 June 1937; WSC's private secretary to Sir John Lavery, 24 February 1937; WSC to Sir John Lavery, 30 June 1937.

69 Rose, *Literary Churchill*, pp. 234-5.

70 Below p. 90.

71 Rose, *Literary Churchill*, pp. 116, 265, 333.

72 Rose, *Literary Churchill*, p. 280.

73 Rose, *Literary Churchill*, pp. 234-5.

74 Rose, *Literary Churchill*, p. 235; Kershaw, I. (1998), *Hitler*, vol. i, *Hubris, 1889-1936*. London: Allen Lane, pp. xxviii, 17-26, 38-9, 42-3, 48, 57, 170, 625, note 262.

75 Rose, *Literary Churchill*, pp. 277-8.

76 Sandys, E. (2015), *Winston Churchill: A Passion for Painting*. Virginia Beach, VA: The Donning Company Publishers, p. 32.

77 Moran, *Struggle for Survival*, p. 83; Gilbert, M. (1986), *Winston S. Churchill*, vol. vii, *Road to Victory, 1941-1945*. London: Heinemann, pp. 313-4.

78 Moran, *Struggle for Survival*, p. 255-8, 266, 294-303; *SFT*, pp. 532-5.

79 Nicolson, *Alex*, p. 325; Soames, *Churchill as a Painter*, pp. 145-6; Churchill, *Thread in the Tapestry*, pp. 89-98; *SFT*, pp. 538-9.

80 Moran, *Struggle for Survival*, p. 322; *SFT*, pp. 544-7, 557; Graebner, *Mister Churchill*, pp. 71-82, p. 141.

81 Cannadine, *Heroic Chancellor*, pp. 47-8; Reynolds, D. (2004), *In Command of History: Churchill Fighting and Writing the Second World War*. London: Allen Lane, pp. 9, 487-90.

82 CHUR 4/4B: K. Hill to WSC, 18 January 1946; R. Pound to WSC, 26 March 1946; Graebner, *Mister Churchill*, pp. 12-14, 44.

83 For earlier correspondence, wishing that 'when the war is over, he will, I hope, appear as a competitor with some of your members', see RAA: SEC 6/10: B. Bracken to Sir Edwin Lutyens, 16 April 1941. See also CHUR 2/323, WSC to Sir Alfred Munnings, 22 May 1947; Sir Alfred Munnings to WSC, 29 May 1947, 9 June 1947, 14 July 1947.

84 RAA: Council Minutes, 22 January 1948, 18 March 1948; SEC/ 1/120: H. Matthews to Sir A. Munnings, 19 January 1948; CHUR 2/323: Sir Walter Lamb to WSC, 29 April 1947; WSC to Sir Walter Lamb, 30 April 1948; Reynolds, *In Command of History*, p. 135.

85 CHUR 4/40: J. Benn to WSC, 6 June 1947; WSC to C. L. Shard, 29 August 1947; C. L. Shard to Nina Sturdee, 1 July 1947, 27 August 1947, 8 November 1948.

86 The book was very widely reviewed: see *Isle of Wight Mercury*, 10 December 1948; *Guardian*, 17 December 1948; *News & Book Trade Review*, 18 December 1948; *Daily Herald*, 20 December 1948; *Western Mail*, 23 December 1948; *Reading Mercury*, 25 December 1948.

87 Below pp. 114, 129-32; CHUR 4/40: H. W. McGraw, jr, to WSC, 15 November 1949; E. Warner to Nina Sturdee, 30 January 1950, 28 March 1950; *Chicago Tribune*, 23 March 1958.

88 CHUR: 2/323, Sir Walter Lamb to WSC, 1 April 1949; 5/ 25A: Mr Churchill's Speech Notes, Royal Academy Banquet, 28 April 1949; 2/163, WSC to Sir Alfred Munnings, 8 May 1949; *The Times*, 29 April, 1949; Gilbert, *Other Club*, p. 93.

89 RAA: SEC/1/120, H. Matthews to Sir Alfred Munnings, 19 January 1948; Black, *Churchill in British Art*, pp. 181-4.

90 R. Rhodes James (1986), *Anthony Eden*. London: Weidenfeld, pp. 59-60, 66-7, 162, 618; Lord Butler (1971), *The Art of the Possible*. London: Hamish Hamilton, pp. 33-4.

91 Gilbert, M. (1988), *Winston S. Churchill*, vol. viii, *Never Despair, 1945-1965*. London: Heinemann, p. 142; Soames, *Churchill: His Life as a Painter*, p. 143.

92 *SFT*, pp. 571-4; Coward, N. (1986), *Autobiography*. London: Methuen, p. 324; Hoare, P. (1995), *Noel Coward: A Biography*. London: Sinclair-Stevenson, p. 398.

93 CHUR 2/345: Sir Gerald Kelly to WSC, 16 April 1953; WSC to Sir Gerald Kelly, 5, 28 March 1954, 6 April 1954; Moran, *Struggle for Survival*, p. 533; *SFT*, p. 555.

94 Below p. 121.

95 Below p. 125.

96 Below pp. 133, 137-8.

97 Rothenstein, J. (1966), *Brave Day, Hideous Night*. London: Cassell, pp. 31, 59, 81, 88, 186, 212-4.

98 Below p. 143.

99 Below pp. 142-3.

100 Moran, *Struggle for Survival*, pp. 679-70.

101 Below p. 101.

102 Soames M. (1979), *Clementine Churchill*. London: Cassell, p. 462; *SFT*, p. 621; Rose, *Literary Churchill*, p. 420; Moran, *Struggle for Survival*, pp. 458, 498, 653, 673, 749.

103 *Kansas City Times*, 27 January 1958.

104 *Chicago Tribune*, 24 April 1958. For a full account of the director's decision to leave, which had in fact been taken before the Churchill controversy blew up, see: AIC: D. Catton Rich to H. McBride, 7 May 1958; M. Kogan, press release, 28 April 1958; Smith, J. W. (1993), 'The Nervous Profession: Daniel Catton Rich and the Art Institute of Chicago, 1927-1958', *Art Institute of Chicago Museum Studies*, xix, p. 78.

105 *SFT*, p. 623; Ramsden, J. (2003), *Man of the Century: Winston Churchill and His Legend since 1945*. London: HarperCollins, pp. 351-3, 391, 421, 469-72.

106 RAA SEC/24/53: G. Jeans to Sir Gerald Kelly, 23 October 1955; WSC to Sir Gerald Kelly, 2 November 1955; Sir Gerald Kelly to WSC, 27 June 1958; CHUR 1/121, Sir Charles Wheeler to WSC, 7 January 1958, 14 July 1958, 16 November 1958; WSC to Sir Charles Wheeler, 10, 28 January 1958, 10 July 1958.

107 For the abortive John portrait of Churchill, see: CHAR 1/324: Mrs Valentine Fleming to WSC, 11 November [1938]; WSC to Mrs Valentine Fleming, 12 November 1938; below pp. 145-6.

108 RAA SEC/24/53: A. John to Sir Charles Wheeler, 29 January, 11 February 1959; A. Montague Brown to H. Brooke, 6 February 1959; A. John to H. Brooke, 6 February 1959; H. Brooke to A. John, 10 February 1959;

H. Brooke to A. Montague Brown, 10 February 1959; CHUR 1/121, H. Brooke to A. Montague Brown, 3 February 1959; A. Montague Brown to WSC, 6 February 1959; A. Montague Brown to H. Brooke, 6 February 1959; *Paintings by the Rt Hon. Sir Winston Churchill exhibited at the Royal Academy of Arts* (London, 1959), preface.

109 For some of the many reviews, see: Rydon, J., 'At 84, Churchill gets the RA all to himself', *Daily Express*, 10 March 1959; Laws, F., 'Sir Winston's Academy show of paintings', *Manchester Guardian*, 11 March 1959; Munro, I. S., 'Oil Paintings by Sir Winston Churchill', *Glasgow Herald*, 11 March 1959; Shaw, H. R., 'The Honorary Academician Extraordinary', *Liverpool Daily Post*, 11 March 1959; Macguire, A. P., 'A bold and joyous brush', *Yorkshire Post*, 11 March 1959.

110 Hussey, C., 'Churchill at Burlington House', *Country Life*, 12 March 1959; below p. 149.

111 *SFT*, pp. 630-3; RAA: Council Minutes, 10 December 1957, 17 February 1958, 4 August 1959; CHUR 1/121, Sir Charles Wheeler to WSC, 4 August 1959; WSC to Sir Charles Wheeler, 16 August 1959; CHUR 2/345, Sir Charles Wheeler to WSC, 17 July 1959; CHUR 1/121: A. Montague Brown to WSC, 17 March 1959, 12 June 1959.

112 Gilbert, *In Search of Churchill*, p. 79; Moran, *Struggle for Survival*, pp. 321, 749; Montague Brown, *Long Sunset*, pp. 226-7; *Daily Telegraph* and *Daily Mail*, 22 October 2017; *The Times* and *Daily Express*, 23 October 2017.

113 *News Chronicle* and *The Times*, 30 April 1959; CHUR 2/345, Sir Charles Wheeler to WSC, 4 March 1960.

114 Nicolson N. (1968, ed.), *Harold Nicolson: Diaries and Letters, 1945-62*. London: Collins, p. 395.

115 RAA RAC/3/CH 7: WSC to Sir Charles Wheeler, 3 May 1963; Howells, R. (1965), *Simply Churchill*. London: Robert Hale, pp. 18, 43-4, 52-3, 69-70, 120-1; below p. 165.

116 WSC (1938), *Marlborough: His Life and Times*, vol. iv. London: Cassell, p. 648; Bonham Carter, *Churchill as I Knew Him*, pp. 23-4; Storr, 'The Man', pp. 235-6; Moran, *Struggle for Survival*, pp. 122, 597, 659, 671; Reynolds, *In Command of History*, p. 525.

117 Moran, *Struggle for Survival,* pp. 300, 393, 417; Cowling, M. (1980), *Religion and Public Doctrine in Modern England.* Cambridge: Cambridge University Press, pp. 284–91.

118 Below p. 111.

119 Rose, *Literary Churchill,* p. 448; Churchill, S. (1981), *Keep on Dancing.* New York: Coward, McCann and Geoghegan, pp. 333–6.

120 Buczacki, *Churchill and Chartwell,* p. 279.

121 Sandys, *Churchill: A Passion for Painting,* p. 12.

122 Moran, *Struggle for Survival,* p. 752.

123 *Daughter of History: Mary Soames and the Legacy of Churchill: An Auction* (17 December 2014). London: Sotheby's, 2014.

124 *The Art of Diplomacy: Winston Churchill and the Pursuit of Painting.* Atlanta: Millennium Gate Museum, 2014, pp. 47-8.

Churchill on Art

1.

'NOT A VERY AMIABLE TOPIC'

Speech to the Royal Academy banquet, Burlington House, London, 4 May 1912

O N BEHALF OF THE British Navy, it is my duty to return you thanks for the manner in which you have drunk the health of the Senior Service. The business of the Admiralty differs from the business of many great public departments in one important aspect. In many offices of State there is a great succession of interesting and important questions which are detached from one another, but at the Admiralty everything contributes and converges on one single object, namely, the development of the maximum war power at a given moment and at a particular point. Upon that precise object are directed all the science our age can boast, all the wealth of our country, all the resources of our civilization, all the patience, study, devotion to duty, and the sacrifice of personal interests which our naval officers and men supply, all the glories of our history in the past – everything is directed upon this one particular point and object, namely, the manifestation at some special place during the compass of a few minutes of shattering, blasting, overpowering force.

This may not, perhaps, seem a very amiable topic to which civilized men should devote many hours of their lives, but yet I venture to think that in the world in which we live and

in the circumstances amid which we find ourselves, the study of absolute force for its own sake is not perhaps altogether unworthy of those who are called upon to take a share in the counsels of a free people. For what lies on the other side? What lies behind this development of the force of war power? Why, Mr President and gentlemen, behind it lie all our right and claims for our great position in the world. Behind it lies all our power to put our own distinctive and characteristic mark upon the unfolding civilization of mankind; for under the shelter of this manifestation we may agree or quarrel as we please, we may carry on our own party politics in perfect security. So long as that quality of our civilization, so long as the patriotism and organization of our country are sufficiently high to enable us to produce the maximum of force at a particular point, there is no reason why we should not hand on undiminished to those who come after us the great estate we have received from those who have gone before.

I would not dwell even for a few moments upon wicked topics without saying that there is a great danger that the study of force and the development of force may lead men into the temptation of using the force they have themselves developed. There is a danger of men and of nations becoming fascinated with the terrible machinery they have themselves called into being, and I think when we refer to it, it is also right for us to remember that if ever we do get engaged in war, or if any of the great civilized and scientific nations of the world become engaged in war, they will all be heartily sick of it long before they have got to the end. For the rest, the best way to make war impossible is to make victory certain, and I am glad to be able to assure you that we see no difficulty in maintaining the main securities

of the country, and in providing an effective margin for our security at all the decisive points, without adding very greatly to the generous provisions which Parliament has made in the past year, and which it will doubtless renew in the years that are to come. I thank you most sincerely, on behalf of the great Service it is my privilege to represent this evening, and for the gracious courtesy which has led you to bear it in mind.

'THE NAVAL GREATNESS OF BRITAIN'

Speech to the Royal Academy banquet, Burlington House, London, 3 May 1913

THE YEAR THAT HAS passed since I had the honour of replying on this important occasion to this toast has been a year of increasing naval power, so far as this country is concerned, and I should like to take this opportunity of acknowledging wholeheartedly the support the Admiralty have received from men of every shade of public opinion and every school of political thought, and the support which has been manifested not only in parliament by those who vote the large sums necessary, but in the country by those who provide these ample supplies for every naval purpose for which the ministers responsible have asked that credit should be granted.

We are now entering on that period of the year when the British Navy is at its strongest. The new system of refits introduced last autumn enables all the most powerful vessels of the Fleet to be constantly and instantly available during the summer months, and this month and for the next few months we attain and maintain our maximum peacetime development. Now, Sir Edward [Poynter], I should not venture to use at all any language which might be considered vainglorious boasting in the presence of my noble friend Lord Morley, who I am sure would not hesitate to rebuke such unseemly

conduct in one who has so long followed him, but I feel that I am entitled to make one observation to this distinguished company. Like anyone else placed in my position, a year and a half ago I endeavoured to turn upon the different features of naval organization, which I had great opportunities of examining, a questioning eye, and I can truthfully and honestly say that after a year and a half of very good opportunity of observing, the confidence which one feels in this tremendous naval organization grows steadily, and the more one knows about it, and the more one understands it, the more sure one feels of the solid and sober foundation upon which the naval greatness of Britain depends. When we talk of naval strength we are accustomed usually to compute it in the number of ships and men, but after all that is no true measure of naval supremacy; quality, and quality in the first place, is what we must depend upon. I am sure you will not be indulging in any unreasonable expectation or hope if you believe that, ship for ship and man for man, our people have no reason to be deemed unequal to any task they may be called upon to undertake. It is only when this question of quality has been effectually disposed of that our great superiority in numbers would need to be carefully examined.

During the year that has passed we have witnessed increasing co-operation with the military forces. The Secretary of State for War and I have been friends since schoolboy times, and his Serene Highness the First Sea Lord is on terms of close and cordial friendship with the distinguished head of the General Staff of the Army. It is very necessary that the Navy and the Army should work together. In an island country and a maritime Empire all warfare tends sooner or later to become amphibious, and a

close, intimate, and flexible co-operation between the forces of sea and land is necessary if we are to develop our full power on either element. There have been times when speakers for the Navy and the naval authorities have been inclined to belittle the part taken by the Army in maintaining the security of the country. Those times are done, and to-day naval men of every school recognize that it is essential for the effective naval defence of those islands that an adequate military establishment should be preserved therein.

I have been racking my brain, Sir Edward, during your sumptuous entertainment, to think of some connection, however far-fetched, between art and our modern battle-ships, but I frankly confess I find it difficult to trace in the outlines of these formidable engines any of those qualities of grace and beauty which, perhaps, in ancient times were associated with ships of the line, and to which you would look as the groundwork of the pictures which should find their place in the exhibition of the year. Modern ships do not afford much ground for artists to work upon, and I am not at all sure whether in the future our developments under the water or in the air are likely to remove that serious defect; so I am afraid we cannot on the aesthetic or artistic side claim any close acquaintanceship with the Royal Academy. Still, Sir Edward, you have touched upon another aspect. The times in which we live are stormy, the shadow of danger darkens the threshold of European civilization. We trust and we believe that it will pass, as it has so often passed before; but, still, you are right at your banquet tonight in comfortable London not to forget the officers and seamen upon whose punctual and faithful fulfilment of their arduous duties the safety, the fortunes and the honour of our country depend.

3.

'ART IN ALL ITS FORMS'

Speech to the Royal Academy banquet, Burlington House, London, 3 May 1919

THE BANQUET OF THE Royal Academy is always an important event, but tonight it is a memorable occasion. Many differences separate the times of the pre-war banquets from the present. Three notable circumstances distinguish the present banquet. The first is the speech of the Prince of Wales. I am sure everyone who was privileged to listen to it heard it with feelings of the very greatest pleasure and of the very highest hope, and with the feeling that a new personality has come upon the field of our British and imperial life to assist in the burden of all those forces which make for the welfare of the British people and nation. Another great contrast between that night and the past banquets is that there are no party politics. The President said that artists know no party politics. I am not so sure of that, but I remember in the days before the war ministers were scowled at by half their fellow countrymen and beamed on by the other half.

The task upon the ministers of the Crown at the present time is really a very heavy one indeed, but at any rate the difficulties we have to face are only the difficulties of circumstances, and the only opposition we have to encounter worth

speaking of is the opposition of events. It is well that that should be so, because the tasks are so heavy and the formidable nature of events are such that it is all that men can do to carry safely through the precious burden entrusted to their care; and if we have anything like the faction and discord and partisan fury which we can afford to indulge in in the times of peace, I do not believe that the immense problems which rush upon us in continuous and unbroken succession can possibly be surmounted.

The third difference impresses itself very much upon me. I remember being at the Academy banquet six years ago, and I think it was five years since the last one. I took the trouble to look up the speeches which were made on the occasion of the last three banquets, and through them all was the presage of war. Every one had a feeling that something was coming; something formidable, something tremendous, something possibly fatal was moving towards us. There was a feeling of great oppression, the sense one has when a thunderstorm is gathering.

Well, the great struggle is over! The great wave has been surmounted, and the ship is sailing safely on the farther side, although the sea might be very rough and the sky very lowering. We have passed through the supreme culminating period in all our lives, perhaps the supreme culminating period even in the history of this country, and we have not failed as a generation answerable to posterity.

Round this table tonight we see the commanders of victorious armies, men who have won victories on a greater scale than Napoleon Bonaparte ever planned, and who have led our peaceful population to war against the great military empires of the world. We also see representatives of the

Navy, which, after all is said and done, rendered the victory of Britain and of civilization a possibility. If we could wish for any event which could truly measure the greatness of our victory, the completeness and indisputability of our victory, what could compare with what so many of us have witnessed that afternoon in the march through the city of London of the united dominions of the British Empire, represented by soldiers of exceptional valour?

Even since the fighting stopped we have made good progress in the solution of all the different and varied problems which the transition from war to peace presents. I am not going into details, but I will say that no reasonable man, looking at the position which we occupy now and comparing it with the peacetime anxiety which we felt when the fighting came to an end, has any cause but to congratulate himself and his country with all sincerity. So far as this country is concerned, it has every evidence that those strong forces, those strong, stubborn, deeply founded British forces which, acting together in every sphere of life, won this war and brought us safely through this peril, were going to be strong enough not only to win the war, but also to secure its fruits and carry the nation through the critical period of transition.

The Prince of Wales in his speech proposed to us the question what effect the war would have upon the spirit of the age in art. At any rate it will set art free. The cessation of this struggle will liberate once again all those cultured forces which are nourished in the bosom of our country, and which grow and develop and reach their fruition in the prosperous times of peace. The field has been harrowed, terribly harrowed! We have only to look at that tragic canvas [John Singer Sargent's 'Gassed'], with all

its brilliant genius and painful significance, to see how the field of national psychology must have been harrowed by the events which have taken place in this war. I will answer his Royal Highness's question by saying that art in all its forms will emerge from this war, as soon as we get clear of all practical difficulties, not merely to the position in which it was when we entered the struggle, but revivified and beautified as it has always been by tragedy, trial, and tribulation.

4.

'ART AND POLITICS'

Speech to the Royal Academy banquet, Burlington House, London, 1 May 1927

T HE PRIME MINISTER FEELS the necessity of bracing himself for the exceptional responsibilities which rest upon him and of concentrating his whole endeavours on their effective discharge. In these circumstances the duty fell to me of delivering a response to the kind words which have been said about his Majesty's Government. I will offer only a few observations, about which I can safely say that they will not command universal agreement.

My first observation is how very lucky artists are. The guests on this occasion must realize that we are entertained by a class of the most fortunate mortals on the globe. All human beings may be divided exhaustively into two classes – those whose work is their toil and those whose work is their joy. Fancy painting all those delightful scenes and graceful forms, tracing the subtle curves of beauty and marking justly where the flash of light falls among the shadow, and doing all that, not as an amusement, but as a solid profession – as a means of earning one's daily bread and paying one's income tax. Fancy at the same time being able to establish a claim on the admiration of contemporaries, and having, in addition, a chance, all the more fascinating because it is unknowable,

of building up an enduring posthumous fame. It sounds almost too good to be true. Looking around these walls we see reflected from them hours of pleasure, hours of intense creative enjoyment, bottled sunshine, captured inspiration, perennial delight. We have been told that Faust sold his soul for the right to command the moment to remain. Our hosts enjoy in complete security, and without the slightest prejudice to their future destination, the power to command the moment to remain, not only for their own advantage and reputation, but for the pleasure of everyone else.

It has been the custom on these occasions most frequently to compare art and politics, to draw distinctions between them and lay stress on the points they have in common. There is a great field of discussion in comparing art and action or painting and politics. I would be prepared to say that all forms of art and action are in principle the same – I say 'in principle' because it is a valuable phrase – but, making allowance for differences of time, circumstances, technique, and so on, all forms of action and art really require at their critical moments the same kind of decisions. If you were building a bridge, planning a house, or making an argument in a book or speech, or framing a Budget, or the programme of a party, or the policy of a nation, or planning a battle on sea or land, you would come across the same sort of decisions and complex propositions requiring flair and judgment as are always presented in the course of painting any large or serious picture.

But in comparing art and politics one may notice particularly their resemblance in the fact that the three dominant elements of each are common to both – colour, proportion, and design. Colour is the most popular – I admire it very much indeed in painting. I am not entirely averse to it in

politics. I rejoice infinitely to see the swift advance of English painters into the full assertion of the force and charm of colour. Still, I must admit that colour ranks far above proportion and design both in painting and politics. It is curious that the sad and crude ages of politics in every country have been those in which people had not been able to express their differences from one another by reasoned argument or scientific or logical principles – they had to choose crude colours – more primary colours – red, black, white, green, blue or true blue. It certainly implies a descent in the level of political action. When colour runs mad, without the discipline of proportion and design and without the harmonies that follow from them, you may be certain, whether in the field of art or action, you are passing through a somewhat stagnant period.

There is one respect in which workers in the field of action have suffered in comparison with those in the field of art. Art is long and life is short; but art has not got any longer and life has not got any shorter in the past century. But in the sphere of action, the scale of events has been multiplied a hundred-fold, while no notable advance in the mental stature of man has yet been discerned by impartial observers. It is on those grounds I feel sympathy is extended to his Majesty's Government, who are sincerely endeavouring, without respect to class or party, without fear, favour or affection, to carry our country through an extremely difficult period of recovery and recuperation forward on its path – are now trying to make the best arrangements which are possible for the present generation of British subjects to live their lives and realize the best that is in them, and make the finest use of the unequalled inheritance that they have received from their forefathers.

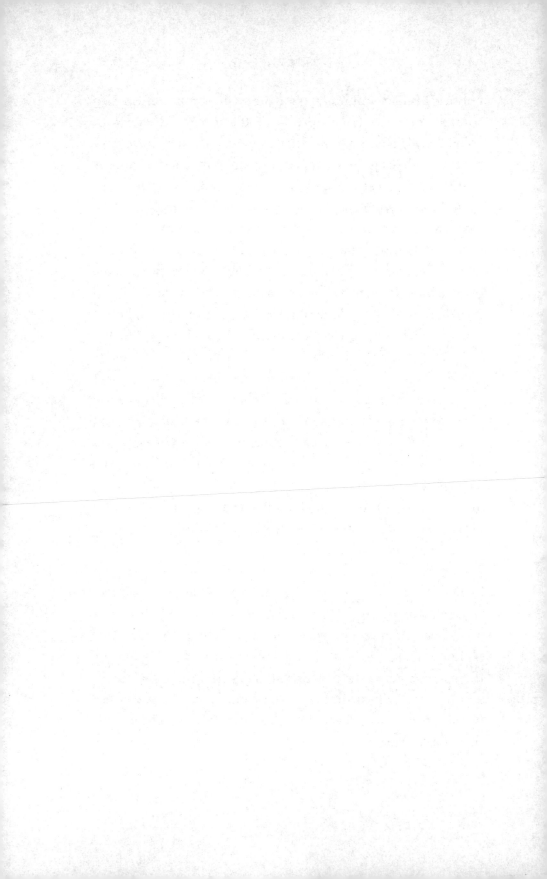

5.

'POLITICAL PAINTERS'

Speech to the Royal Academy banquet, Burlington House, London, 30 April 1932

IT IS VERY CHARACTERISTIC of the chivalry of the Royal Academy that you should, on this occasion, have picked out among all the politicians who were at your choice for the places of honour at your gathering the Home Secretary [Sir Herbert Samuel] and myself, two of the least understood politicians outside that festive scene. Here we find sanctuary. I would not dream of lecturing the Royal Academicians on your art. Outsiders might do that but, as a humble amateur, I treat with the greatest possible disciplinary respect the eminent leaders of the profession. I will tell you something about another 'Academy': not only a 'Royal Academy', but at the present time a 'National Academy', and it resides at Westminster, from which quite a number of the guests have come tonight. The National Government has a great deal in common with the Royal Academy. It is not so ancient, and it may not live so long – but it meets an indubitable public need, and it embraces – I am not quite sure that the word 'embrace' was well chosen, but I will let it pass – every style and every shade of political artistry.

I must tell you about some of the leading political painters. First of all there is the Prime Minister [Ramsay

MacDonald]. How glad we all were to learn that his health is so much better. His works are well known. We all regret that they are not more frequently visible at home. He has been exhibiting so much in foreign countries lately that we rather missed his productions here. I believe that on the continent he has several most important masterpieces still unhappily in an unfinished condition – and we look forward hopefully to their arrival and to his return. I have watched for many years the Prime Minister's style and methods, and for a long time, I do not mind saying, I thought there was a good deal too much vermilion in his pictures. All those lurid sunsets of capitalist civilization began rather to pall upon me, and I am glad to see he has altered his style so fundamentally. In all his new pictures we see the use of cobalt, of French ultramarine, of Prussian blue, and all the other blues – not excluding, I am glad to say, the British true blue – that cerulean, that heavenly colour we all admire so much. I think the Prime Minister in his pictures uses blue very much like the late John Sargent, not only for atmosphere but for foundation, and I personally like his modern style very much better than the earlier method.

Then there is the Lord President of the Council [Stanley Baldwin], who, I can assure you, is still quite a distinguished painter in our Academy. If I were to criticize him at all, I would say that his work lacks a little in colour, and also is a little lacking in the precise definition of objects in the foreground. He, too, has changed in his later life not only his style but also his subject. We all miss very much the jolly old English pictures which he used to paint – 'The Worcestershire Farm', 'Pigs in Clover' and 'Broccoli in Autumn'. Above all, we miss just now that subject which no pencil could have done more

justice to than Mr Baldwin's – 'Brewing the Audit Ale'. Making a fair criticism, I must admit that there is something very reposeful about the half-tones of Mr. Baldwin's studies.

Then we have in our Academy the Dominions' Secretary [J. H. Thomas], who represents what I might call a very fruity type of cubism. Some people think it shocking; others say it lacks conviction. That is a very serious criticism, is it not? Nevertheless, it is certainly a most interesting contribution to our national show. I trust you will want to ask me how it is that I am not exhibiting these days. Why is it I have not got a row of important pictures on the line at my Academy? I will be perfectly frank with you. I make no concealment; I have had some difference with the committee – the hanging committee. Luckily their powers are limited so far as I am concerned, and I am not submitting any of my works for their approval this year. I have joined the teaching profession. We have a sort of Slade School at Westminster. They are a fine lot of young students, most ardent and with much before them – to learn. I am endeavouring to assist them in acquiring a knowledge of parliamentary technique. I have a few things on the easel of my own which I hope some day to present to the public. After telling you these few things about our political academy I am sure the company will join with me in drinking the toast of your own.

6.

'THE ACADEMY REVEALS BRITAIN'S BRAVE GAIETY'

Daily Mail, 7 May 1932

A GREAT DEAL OF fun is poked, much of it with justice, at the modern habit of inviting persons whose names are for any reason known to the public, to air their views on subjects which are not their own. But there is something to be said for the venting of non-specialist opinion. After all, the appeal of the Arts, with which we are here concerned, is ultimately to 'the general'; and it is all to the good that members of that body should now and then give expression to their response, provided it is understood that if they do not speak as the scribes neither do they speak with authority. It is also, I think, true that an artist by profession is likely to have his judgment swayed by his own artistic tendencies, while an outsider has more freedom to be catholic. I myself, though I am not without having handled a brush, have never carried practice far enough to become involved in any particular line of aesthetic thought, and can gather the harvest of an unprejudiced eye.

But, confronted with the Royal Academy Exhibition, even a specialist might well feel diffident. The oil paintings alone number this year 681, and they are of necessity hung so close together that it is a real exercise of concentration to isolate them and consider each in its own entity: nowhere are

'the spurns that patient merit of the unworthy takes' better exemplified than when a quietly beautiful piece is shouted down by a garish neighbour. To look properly at a hundred pictures a day is all that may become a man: and here are enough to take up more than the working days of a week. Injustice is therefore unavoidable, and on any other footing than that of exchanging notes with the public of which I am a member I could not consent to speak. In any case, my object will be to pick out the works which I can praise, not those which I should like to bury.

First and supreme there reigns throughout these scenes the youthful genius of the lamented Orpen, whose memory is honoured by the inclusion of three early works. The beauty and imaginative power of the 'Play Scene from *Hamlet*' must be banished from the mind before the many other excellent pictures in the big room can get their due. It is such a sight as a young (and slightly mocking) poet might dream on his way to the Old Vic. The lovely, shimmering-green 'Empty Bed' and the radiant portrait of his wife have the same glow of inspiration, and put in the shade the high competence of his later likenesses. Sir John Lavery has often laid his alert observation and agile hand at the joint service of history and art in recording the scenes and events of our national life, and his painting of 'Their Majesties' Court' is the crown of his achievement in this kind. The accuracy of the representation has not conflicted with the broad sweep of the design or the subtly echoing colour of the ladies' gowns, the uniforms of the men, the blue-grey walls, and the 'starry lamps and blazed cressets' above. A somewhat similar subject, 'The Opening of Parliament, Ottawa', is also admirably presented by Mr Richard Jack.

In a perfect world Mr Sickert's 'Raising of Lazarus' would have a wall to itself. The emerald green of the lower figure, enhanced as it is by the pale gold beside it and the great burst of crimson above, is as gorgeous a tincture as has ever been put on canvas. The extreme deadness and mattness of the black background is made to look unintentional by the dabs of shiny paint which fleck it here and there, and we might be more comfortable if it had a coat of varnish; but this, even if I am right, is nothing in comparison with force of the design and the splendour of the colour. The president's presentation pieces are admirable in their dignified reserve, and Mr Francis Dodd shows a masterly portrait of Lord Hugh Cecil in which he has combined the sterner side of his character with the solution of what must have been a difficult technical problem in the subduing to an astringent harmony of the queer orange and maroon of the doctor's gown. Mr Oswald Birley's picture of Lord Irwin in full panoply is so like that it almost speaks.

Another portrait which interested me on personal grounds was Mr Wheatley's luminous 'General Smuts', apparently disposing himself to play cat's cradle; but the painter's palette seems to have been invaded by a strong detachment of custard powder. Mr Gerald Kelly has reached No. XXXII in his charming and accomplished series of 'Janes', and it is a like tribute to Hymen that Mr de Glehn's 'The Beloved' is probably his masterpiece. Mr Connard has two excellent small-figure groups in the first room. He has suffused the Arts Club with a light that never was in club or bar, and it would be amusing to see the members in Mr Nowell's version transfigured in it. 'The Reggie Grenfells' would perhaps have been almost too dramatic if the lady had been

given anything to look at with the intensity which her husband is bestowing on the tongue of her Pekingese. Boswell tells us that Lord Clive committed suicide because he was 'weary of still life'; but his lordship would have survived the present exhibition. There is a strange absence of the apples, loaves, guitars and dishcloths which pervade the general run of galleries, but I noticed some pleasant flower pieces by Mr Stephen Bone and Miss Cecil Leslie.

Landscapes, on the other hand, are bewilderingly many. Mrs Swynnerton's 'Storm-tossed Willow', in its perfect spontaneity and authenticity, is perhaps in a class by itself; but great pleasure may also be had from Mr Talmage, Mr Sydney Lee, Mr George Graham, Mr Bateman, Mr Lamorna Birch, Sir H. Hughes-Stanton, with his fine eye for a subject, Mr Arnesby-Brown's 'The Beach', with its splash of sunlight in the foreground against the lovely greys of the sky, and Mr Oliver Hall's austere but tender browns, especially in his 'Alcantara Bridge'. Mr Munnings breaks new ground in 'From my Bedroom Window', triumphantly gay and summery, with its background of candle-kindled chestnut trees. Few will be able to pass by carelessly Mr Mark Symons's 'In the Street of the Great City'. The sharp contrasts of its tessellated design attract the eye from afar. Many will be affronted or distressed by a close inspection. We do not think that they will be any the worse for the varying messages which issue from the canvas. It is at the least a remarkable ceiling piece.

In the pictures for the Bank of England the artists give a remarkable and theoretically laudable display of teamwork, in which they seem to find the lowest common factor of their talents; it is almost impossible to tell one man's work from

another's, and this self-abnegation, perhaps, accounts for a general air of stiffness and aridity which is emphasized by the adjacent vividness of Mr Gunn's trio of distinguished writers. To those for whom the Academy is incomplete without a 'problem picture', I commend 'A Director Announcing the Bank Rate to the Chief Officials', which for this purpose should be renamed 'Breaking the News'. The problem would be: is the Bank Rate up or down? As we gaze upon the faces and immaculate tailorings of these rulers of the City of London, who have guided our monetary policy through these eventful years until it has reached almost perfect stultification, we cannot help wondering whether these panels will be an inspiration to the future generations in the Bank of England. They may, at any rate, serve as monitors against much that should be avoided both in finance and art.

The architectural room is not in my province, but I cannot end these random remarks without congratulating Sir Edwin Lutyens, Liverpool, and the Pope on the magnificent series of designs for the Metropolitan Cathedral. The general and final impression of this year's Royal Academy is most pleasing. There is an almost complete absence of slovenly or impudent work. Care and fidelity in definition and value are distinguished throughout the galleries. Aspiring painters are taught that a high level of technical proficiency with brush and pencil is one of the criteria by which they will be judged. Excursions into bizarre impressionism may be accepted from those who have proved their credentials. But slap-dash and short cuts to fame or notoriety are evidently, and rightly, discouraged. My other prevailing impression is the gaiety and love of colour which characterize our art at the present time. We do not have much sunshine in our island,

but the English people in every walk of life delight in flow-
ers and gardens, and greet our grey skies with more flow-
ers than any other people grow. This year's Royal Academy
reflects with remarkable, if unconscious, truth this English
and island taste.

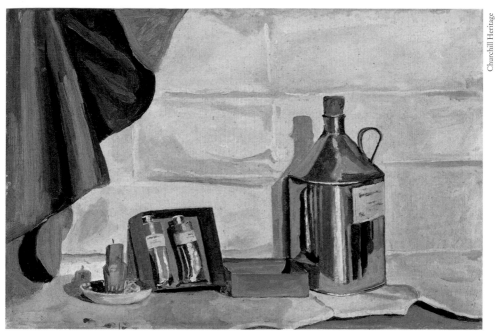

Churchill Heritage

17. Studio still life, c. 1930. Churchill preferred to work in the open air, but if the weather was bad, he would paint indoors.

18. Loch Scene on the Duke of Sutherland's Scottish estate, c. 1930. As this dull picture suggests, Churchill preferred sun-lit coastlines to brooding mountains.

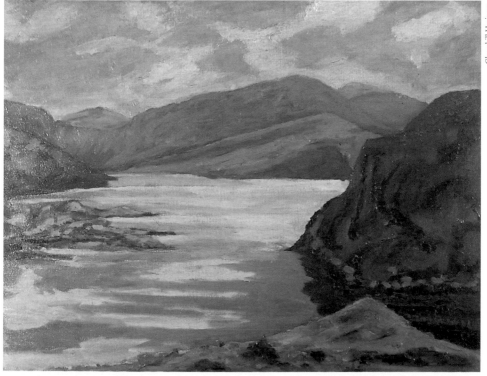

Churchill Heritage

19. Magnolia, 1930s. Many of
Churchill's indoor paintings
were of vases of flowers.

20. North Porch at the Manor
House, Cranborne, 1930s.
Churchill gave this painting to
Viscount Cranborne, who lived
there, and later became fifth
Marquess of Salisbury.

Churchill Heritage

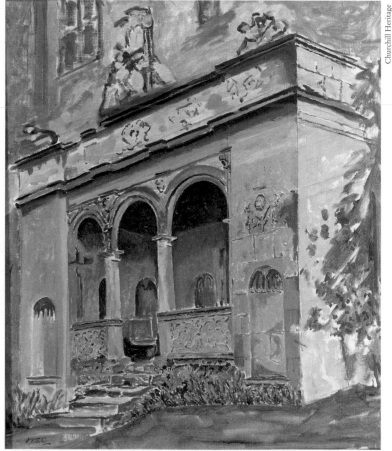

Churchill Heritage

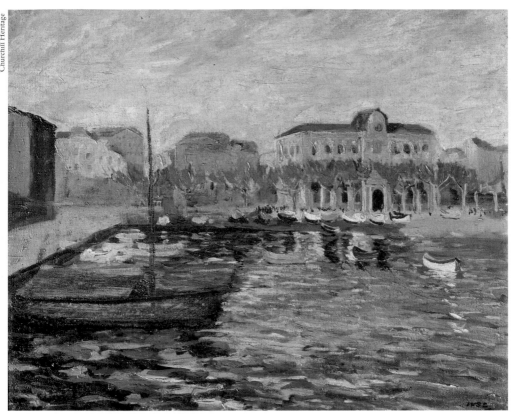

21. Harbour, Cannes,
1933. A quintessential
Churchill rendition
of a sun-drenched
Mediterranean coastline.

Churchill Heritage

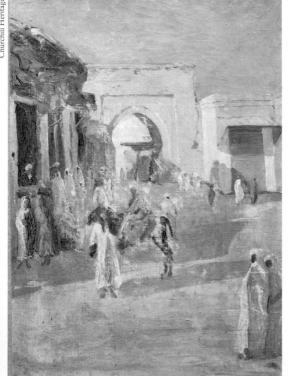

22. Marrakech, c. 1935. One of
Churchill's first paintings of the
Moroccan city where he (but
not Clementine) would spend
so much time in his later years.

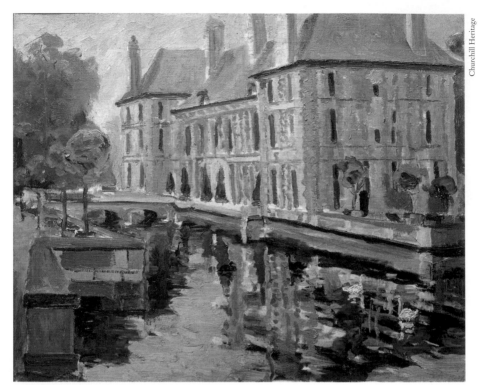

Churchill Heritage

23. Château at St Georges-Motel, 1935-36. The summer home of Consuelo Balsan, who had divorced the Duke of Marlborough and married a rich Frenchman.

24. Chartwell in Winter, c. 1935. This view from the house looks over Churchill's studio (left) and beyond to the Weald of Kent. It was a vista of which he never tired.

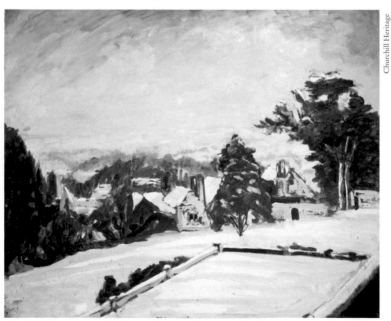

Churchill Heritage

Churchill Heritage

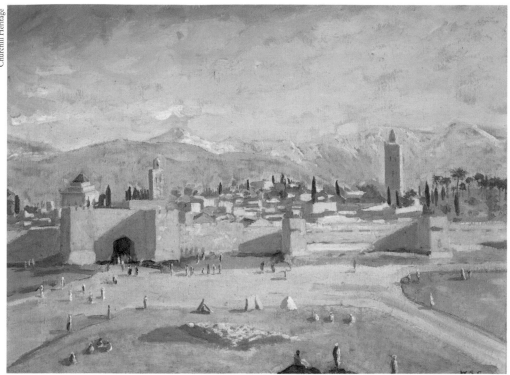

25. View of Marrakech, 1943. Churchill's most famous painting: the only one he completed during the Second World War, which he gave to President Roosevelt.

Churchill Heritage

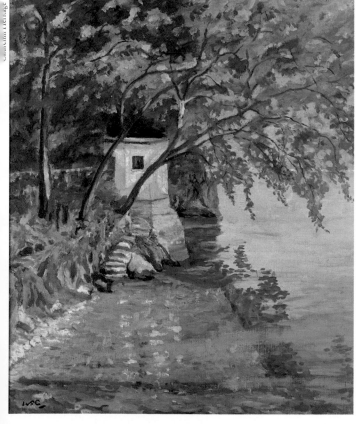

26. Scene on Lake Como, 1945. A similar picture was also painted at the same time by Field Marshal Alexander who, like Churchill, was both a soldier and an artist.

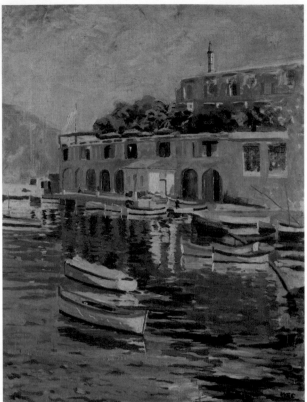

Churchill Heritage

27. St-Jean-Cap-Ferrat,
1946. Another warm and
brightly lit Mediterranean
coastline: the sort of view,
and the sort of painting,
that helped Churchill
recover from his electoral
defeat of the previous year.

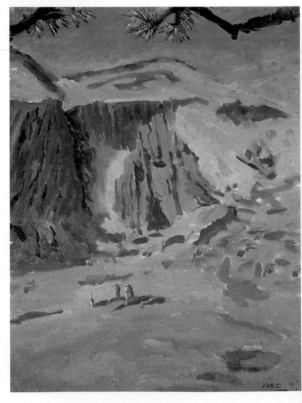

28. The Gorge at Todra,
1951. Completed while
Churchill was once again
staying at Marrakech,
working on his war
memoirs and relaxing
with his paints.

Churchill Heritage

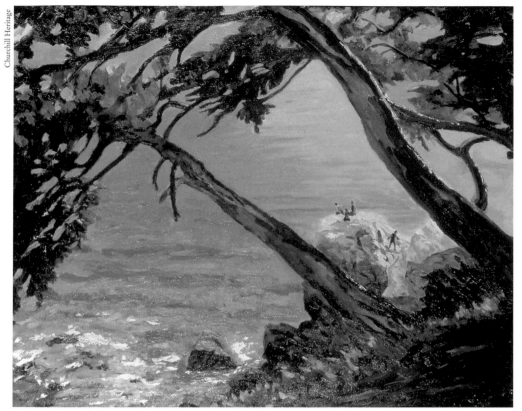

Churchill Heritage

29. Cap d'Ail, 1952. One of the few paintings Churchill completed during his peacetime premiership: a view of the Mediterranean from La Capponcina, Lord Beaverbrook's villa.

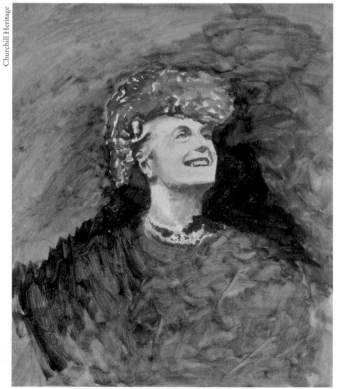

30. Clementine Churchill at the launching of HMS *Indomitable*, March 1940. Painted in August 1955, soon after Churchill's retirement, and based on one of his favourite photographs of his wife.

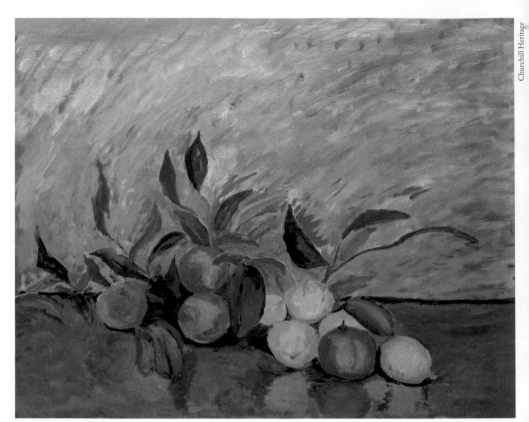

Churchill Heritage

31. Oranges and Lemons, 1958. This still life had been arranged by Wendy Reeves who, with her husband Emery, gave Churchill lavish hospitality during the late 1950s at their French villa, La Pausa.

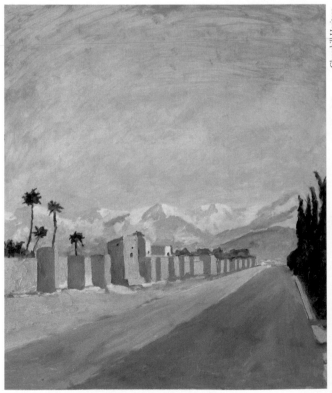

Churchill Heritage

32. Walls at Marrakech, 1959. One of Churchill's last paintings, from his final visit to Morocco. The light and the warmth are gone, and the melancholy is back.

7.

'THIS YEAR'S ROYAL ACADEMY IS EXHILARATING'

Daily Mail, 16 May 1934

I T IS PROBABLE THAT no modern manual of polite con-
versation has ventured to omit from its list of topics rec-
ommended to social beginners the question whether or not
the Academy is better this year than last; and the subject
is undoubtedly one of legitimate public interest. The Royal
Academy is first and foremost a national institution, like
the Poet Laureateship or the Derby. It is the means which
our country has chosen to acknowledge the existence and
the importance of the graphic arts; and the ordinary man
of good will pays his annual visit to its exhibition in the
spirit in which he goes to the Boat Race, or has a bet on
the favourite at Epsom. Compared with the Academy, the
minor societies and one-man shows are holes and corners –
deep holes, perhaps, leading down into the heart of things, or
sunny and sequestered corners where the fruits of art may
ripen. They are the nurseries of experiment and transition;
and in an ideal world the Academy would watch the growth
of each new tendency and, if it made good, adopt it at the
fitting moment into her family.

In an ideal world, moreover, the advancing artists would
lend themselves to the process, and gracefully accept the

judiciously belated overtures of the great mother when these came. Thus the enormous resources and prestige of the Academy would not be wasted on the extremes of either traditionalism or novelty-hunting; the ugly ducklings would in due season take their place as swans; and the general public taste would broaden slowly up from President to President. But the world is well known not to be ideal, and the benign process which I have tried to imagine is in practice patchy and jerky. One year the Academy will make a grab at eccentricity, and the next recoil into over-orthodoxy. On the other side those of the progressive artists who accept adoption seem to lose interest and cease to play up; while others, whose absence is deplorable and even comic, are still, whether by their own default or the Academy's, outside the fold.

Surely it is more than time – to take a few names at random – that Mr Duncan Grant, Mr Matthew Smith, and Mr Arthur Nash should be among those exhibitors their country puts foremost year by year. But 'these thoughts full counsel must mature.' To go back to my initial question, how this exhibition compares with its predecessors, I think the answer must on the whole be favourable. The general level of competent workmanship is probably higher than ever. Secondly, there are very few of those elaborate and too meaningful allegorical or other contraptions by which a certain type of would-be artist demonstrates the fallacy about genius and taking pains. Coming to particulars, there is one case which must at once be squarely faced. I am told on all hands that Mr Stanley Spencer is an artist of the highest endowment and of the most indubitable sincerity, and that in portraiture, in landscape and in religious painting he has given proof of his

quality. But I am not to be intimidated even by what Anatole France calls 'the fear of offending against Beauty unknown' into praising, or acquiescing in, the present representation of his talents. Milton's Sin is at any rate provided with an explanation why 'with fear and grief Distorted all my nether parts thus grew Transformed'; but these misshapen figures, 'abortive, monstrous or unkindly mixed', more fit for Limbo than for the English countryside, are given nothing to say for themselves. The predicaments in which they are exhibited are as unaccountable as their structure.

The work in which it is easiest to recognize Mr Spencer's gift is the 'Portrait', which gives us a rugged and powerful design, and fine and searching draughtsmanship, though even here some parts of the face look as if they had been studied under a stronger magnifying glass than the rest. But if it be true, as a distinguished critic has hinted, that fifty years hence these paintings will be recognized as the heralds of a new dawn, we may surely congratulate ourselves on our present twilight. Just as we shall never know if the one improper joke in Liddell and Scott's *Greek Lexicon* was intentional or inadvertent, we may continue to speculate whether or not the Hanging Committee saw the humour of two of their collocations. The visitor who learns from his catalogue that No. 75 is 'Combing her Hair' will be irresistibly tempted to rechristen its neighbour No. 73 'Combing her Hare'; and is it by accident that we find Mr Monnington's 'Lord Jellicoe' averting a furtive gaze from the flashing and contumelious eye which Mr Cowan Dobson's 'Lord Beatty' is directing upon him from the opposite wall?

Mr Monnington's other portrait, 'Mr Baldwin', has great dignity, and is an excellent likeness, except that the head

seems a little too small. The gold embroideries on the gown are painted with mediaeval precision. Mr James Gunn has not yet eclipsed the masterly presentment of three writers which made a sensation two years ago. His 'Lord Lee of Fareham' is overwhelmed in the eye-piercing splendour of his lordship's robes, but his 'James Pryde Esq.' is an imposing work with a nearer approach to pleasing colour than he usually compasses. The veteran Sir John Lavery is to be warmly congratulated on the inexhaustible vigour of his contributions. His 'Prime Minister at Lossiemouth' is a charming conversation piece, and 'Miss Diana Dickinson' is full of grace and life.

Mr Sickert's 'Sir James Dunn' could only be the work of a master. Miss Cathleen Mann's 'Prince George' is distinguished among royal portraits by its combination of character with sensitive handling. Mr Gerald Kelly is developing a delightfully intimate style of portraiture in which the sitter is shown among the properties of his business; his 'Sir Almroth Wright', in particular, looks as happy among his rows of test-tubes and bottles as Pip thought Mr Pumblechook must be from having so many little drawers in his shop. Mr Meredith Frampton's wise and stately 'Bishop of Exeter' is a true pillar of the Church, and Mr Victor Hammer's tempera self-portrait is a notable design carried out in an original and consistent colour-scheme. There is a pleasant touch of humour in Mr Neville Lewis's masterly 'Henry Rushbury', and a pallid grace in Mr Neville Lytton's 'Les Toits de Paris'.

I am sorry not to be able to congratulate Dame Laura Knight on the account to which she has turned her opportunity of painting the Duchess of Rutland; but Mr Henry Lamb has filled his picture of his wife with palpitating colour

and life. Miss Ethel Walker's 'Melody' and 'Spanish Gesture' are fine examples of an artist whose reputation is rapidly overtaking her merits. Sir William Rotherstein's 'Two Students' beautifully combines the suave and the austere, and Mr A. K. Lawrence's series of men is crowned by an attractive and well-ordered family group. Mr Rex Whistler's skied portrait of the Misses Dudley Ward has a charm and solidity of its own, apart from its merits as a revival of a bygone mode.

I have only skimmed the portraits, but now I must turn to the landscapes. I cannot understand why no greater fuss is made about the noble scenes that Mr Oliver Hall tinges with a consistency of tenderness and melancholy which yet never degenerate into monotony. In each of his pictures, as the eye reaches them, it finds a point of rest and satisfaction. Mr Terrick Williams is another artist who paints from one palette, of greys and blues and greens, but every time with a new delicacy and delight. His loveliest piece here is 'Sun and Mist, Mousehole', which gives the essence of all fair-weather dawns on boat-ridden harbours. Mr Arnesby Brown is, as always, a standby and a mainstay of the show. There is a questionable passage in his 'Round Tower' – a cloud with which Hamlet might have puzzled Polonius; it is 'very like a field'. Mr Munnings pleases me most with his delicate white-and-brown snow piece, 'Winter at Flatford'. His two 'Troopers, Scots Greys, 1807', adapted from contemporary painted statuettes, are an amusing but, I think, not quite successful experiment: the vivid setting of actual warfare in which he has placed them conflicts too violently with the spick-and-span uniforms, fresh from the tailors, which were appropriate to his models. There are some

admirable townscapes. Mr Charles Cundall's 'Piccadilly Circus' shows the same skill in the marshalling of detail as his 'Derby Day'. Mr Henry Bishop charmed me with the simplicity and clarity of his 'Sky and Roofs, Durham'; and Mr Algernon Newton, in his 'Townscape', suffuses a dreary scene with the consecration of serene light which is his secret magic.

I cannot end these brief and partial notes without paying tribute to two lamented artists whose works are among the illustrations of the exhibition: Robert Bevan, whose 'Horse Sale at the Barbican' is a feather in the cap of the Chantrey Trustees, and Annie Swynnerton, whose genius, displayed in four examples, shines forth most brightly in the enchanting 'Gipsy Girl'. But the general impression of the exhibition is exhilarating. No one who visits this year's Academy will spend his time there without pleasure and instruction.

8.

'SEA POWER' IN ART

Speech at the art exhibition opening, New Burlington Galleries, London, 27 July 1937

I NOTICED THIS MORNING in *The Times* an appreciative criticism which nevertheless has its double edge. 'Sea Power', said the distinguished critic, which is the general title of the exhibition, may mean either the power of the sea as an element or the command of the sea for naval and mercantile purposes, and, since emphasis upon the latter would exclude some very fine sea painters – Turner, for example – any Maritime Art Society that is formed would do well to decide whether the more inclusive or the narrower scope is intended.

To interpret sea power merely as the power of the sea would be to give the words their narrower scope, whereas power over the sea implies the wider scope; I have no doubt that it is the second, and not the first, that would afford the widest scope for artistic effort. Sea power, in the sense of the power of the sea, would no doubt be very important in studying some question of coast erosion on the Norfolk shore, or if it were necessary to build another esplanade at Margate, or if we were designing anti-rolling tanks for the *Queen Mary*. But it is when one comes to the great issues of power over the sea that one feels the contact with the

immemorial past of Britain, and the romance of the story which has led us from so barbaric and subjugated an island to our present still respectable position.

There is also the question of whether the exhibition is to be characterized under the heading of art or of propaganda. I do not see why the two should not be combined, although they are not always combined. The other day, across the North Sea or German Ocean, a very great man, who is certainly a master of progapanda, favoured us with his views on art. They were very drastic and formidable pronouncements. I would feel it a very hazardous employment in some countries to be an amateur artist. If you had only the alternatives of being hung if your picture were accepted or hanged if it were rejected, it might put a great damper on individual enthusiasm.

It seems to me that, of all the countries in the world, this country is the one that should direct the attention of painters to the sea, and to the great ships that sail upon the sea. In the endless interpretations of those changing forms we will find a source of inspiration and a source of culture which ought to contribute to the general movement of our island life.

9.

'WE OUGHT INDEED TO CHERISH THE ARTS'

Speech to the Royal Academy banquet, Burlington House, London, 30 April 1938

I AM HEARTILY GLAD to be called upon to discharge this task this year, because I think it is particularly a time when this great gathering should give its support in no perfunctory mood to the Royal Academy. I have noticed several things that have happened lately, and I propose to express my opinion about them with all that freedom which distinguishes artistic circles. Some eminent painters, among whom I have several friends, remind me of high-mettled palfreys prancing and pawing, sniffing, snorting, foaming, and occasionally kicking, and shying at every puddle they see. Of course, this is only a picture which arises in my imagination, but I think we ought to get Mr Munnings to execute it in reality one of these days. I assure him it would have a very good chance of being hung. It is very remarkable that, while our politicians get tamer and tamer – I mean, of course, in the best sense – our artists seem to get fiercer and fiercer. Some of them find a remedy for every difficulty in resignation. The slightest difference, not of morals, or doctrine, or policy, but merely a question of taste, is sufficient to make an eminent artist send in his cap and jacket.

We are very glad that the Prime Minister, amid his many anxieties, has found time and vitality to come here tonight. I was rather afraid, when I read some of these happenings to which I have referred, that he would have felt he would have to carry the policy of 'Keep out' into another sphere. I am sure of this – that he never would have been able to come here if the same intense standards prevailed at Downing Street as at Burlington House. Fancy what his life would be if, for instance, two or three of his leading Cabinet colleagues tendered their resignations because I presented some oratorical work at Westminster and he was alleged to have received it with inadequate appreciation.

On the whole I find myself on the side of the disciplinarians. Of course one may go too far, but no large organization can long continue without a strong element of authority and respect for authority. There must be in any really healthy, effective body – here, perhaps, I touch on delicate ground in the presence of so many ministers of the Crown – yet I will risk it – a sense of collective security. It is a broad question whether any measure of regimentation is compatible with art. In another country – which certainly shall be nameless – an artist would be sent to a concentration camp for putting too much green in his sky, or too much blue in his trees. Even more grievous penalties would be reserved for him if he should be suspected of preferring vermilion to madder brown. We should all agree that such rigour is excessive over here, but surely there is a happy medium which preserves order and regulates traffic without hampering wayfarers.

The arts are essential to any complete national life. The state owes it to itself to sustain and encourage them. The country possesses in the Royal Academy an institution of

wealth and power for the purpose of encouraging the arts of painting and sculpture. It would be disastrous if the control of this machine fell into the hands of any particular school of artistic thought which, like a dog in a manger, would have little pleasure itself, but would exclude all others. The function of such an institution as the Royal Academy is to hold a middle course between tradition and innovation. Without tradition art is a flock of sheep without a shepherd. Without innovation it is a corpse. Innovation, of course, involves experiment. Experiments may or may not be fruitful. Certainly it is not the function of the Royal Academy to run wildly after novelty. There are many opportunities and many places for experimental artists to try their wings – and it is not until the results of their experiments have won a certain measure of acceptance from the general agreement of qualified judges that the Royal Academy can be expected to give them its countenance.

The Royal Academy in recent years has given evidence of its wish, its will, to proceed in the direction of embracing the novel. It has enlisted the services of more than one artist whose work runs counter to its normal predilections, but which at the same time has won the esteem of independent opinion in spite of the cleansing hydrants of criticism. Some of those artists then have been given ample opportunity of influencing the policy of the Royal Academy. We must ask, have they used their opportunity? May it not be said that some of them have seized upon comparatively small occasions to demonstrate their independence and squander their chance of guiding the artistic conscience of the nation into new paths?

I strike this somewhat serious note because of the indispensable service which the Royal Academy renders

to British art. Never was it more needed than at present. Many facilities that existed for a long time are now lacking. The Grosvenor Gallery is finished; the Grafton Gallery and the New Gallery are closed; the New English Art Club struggles bravely on; but the Royal Academy is the one great supreme place that is left nowadays where anyone from dustman to duke – though I am not sure that either class is represented on these walls tonight – can send in what he likes, free, gratis and for nothing, and be assured that he has a broad tolerance and fair play. Here, then, is a strong, precious, and enduring aid which can be given to British painting and sculpture.

In this hard material age of brutal force we ought indeed to cherish the arts. The Prime Minister, who spoke with so much feeling and thought on this subject, has reminded us of the old saying that it is by art man gets nearest to the angels and farthest from the animals. Indeed it is a pregnant thought. Here you have a man with a brush and palette. With a dozen blobs of pigment he makes a certain pattern on one or two square yards of canvas, and something is created which carries its shining message of inspiration not only to all who are living with him on the world, but across hundreds of years to generations unborn. It lights the path and links the thought of one generation with another, and in the realm of price holds its own in intrinsic value with an ingot of gold. Evidently we are in the presence of a mystery which strikes down to the deepest foundations of human genius and of human glory. Ill fares the race which fails to salute the arts with the reverence and delight which are their due.

10.

PAINTING AS A PASTIME

1948

M ANY REMEDIES ARE SUGGESTED for the avoidance of worry and mental overstrain by persons who, over prolonged periods, have to bear exceptional responsibilities and discharge duties upon a very large scale. Some advise exercise, and others, repose. Some counsel travel, and others, retreat. Some praise solitude, and others, gaiety. No doubt all these may play their part according to the individual temperament. But the element which is constant and common in all of them is Change.

Change is the master key. A man can wear out a particular part of his mind by continually using it and tiring it, just in the same way as he can wear out the elbows of his coat. There is, however, this difference between the living cells of the brain and inanimate articles: one cannot mend the frayed elbows of a coat by rubbing the sleeves or shoulders; but the tired parts of the mind can be rested and strengthened, not merely by rest, but by using other parts. It is not enough merely to switch off the lights which play upon the main and ordinary field of interest; a new field of interest must be illuminated. It is no use saying to the tired 'mental muscles' – if one may coin such an expression – 'I will give you a good rest,' 'I will go for a long walk,' or 'I will lie down and think of nothing.'

The mind keeps busy just the same. If it has been weighing and measuring, it goes on weighing and measuring. If it has been worrying, it goes on worrying. It is only when new cells are called into activity, when new stars become the lords of the ascendant, that relief, repose, refreshment are afforded.

A gifted American psychologist has said, 'Worry is a spasm of the emotion; the mind catches hold of something and will not let it go.' It is useless to argue with the mind in this condition. The stronger the will, the more futile the task. One can only gently insinuate something else into its convulsive grasp. And if this something else is rightly chosen, if it is really attended by the illumination of another field of interest, gradually, and often quite swiftly, the old undue grip relaxes and the process of recuperation and repair begins. The cultivation of a hobby and new forms of interest is therefore a policy of first importance to a public man. But this is not a business that can be undertaken in a day or swiftly improvised by a mere command of the will. The growth of alternative mental interests is a long process. The seeds must be carefully chosen; they must fall on good ground; they must be sedulously tended, if the vivifying fruits are to be at hand when needed.

To be really happy and really safe, one ought to have at least two or three hobbies, and they must all be real. It is no use starting late in life to say: 'I will take an interest in this or that.' Such an attempt only aggravates the strain of mental effort. A man may acquire great knowledge of topics unconnected with his daily work, and yet hardly get any benefit or relief. It is no use doing what you like; you have got to like what you do. Broadly speaking, human beings may be divided into three classes: those who are toiled to death, those who

are worried to death, and those who are bored to death. It is no use offering the manual labourer, tired out with a hard week's sweat and effort, the chance of playing a game of football or baseball on Saturday afternoon. It is no use inviting the politician or the professional or business man, who has been working or worrying about serious things for six days, to work or worry about trifling things at the weekend. As for the unfortunate people who can command everything they want, who can gratify every caprice and lay their hands on almost every object of desire – for them a new pleasure, a new excitement is only an additional satiation. In vain they rush frantically round from place to place, trying to escape from avenging boredom by mere clatter and motion. For them discipline in one form or another is the most hopeful path.

It may also be said that rational, industrious, useful human beings are divided into two classes: first, those whose work is work and whose pleasure is pleasure; and secondly, those whose work and pleasure are one. Of these the former are the majority. They have their compensations. The long hours in the office or the factory bring with them as their reward, not only the means of sustenance, but a keen appetite for pleasure even in its simplest and most modest forms. But Fortune's favoured children belong to the second class. Their life is a natural harmony. For them the working hours are never long enough. Each day is a holiday, and ordinary holidays when they come are grudged as enforced interruptions in an absorbing vocation. Yet to both classes the need of an alternative outlook, of a change of atmosphere, of a diversion of effort, is essential. Indeed, it may well be that those whose work is their pleasure are those who most need the means of banishing it at intervals from their minds.

The most common form of diversion is reading. In that vast and varied field millions find their mental comfort. Nothing makes a man more reverent than a library. 'A few books', which was Lord Morley's definition of anything under 5,000, may give a sense of comfort and even of complacency. But a day in a library, even of modest dimensions, quickly dispels these illusory sensations. As you browse about, taking down book after book from the shelves and contemplating the vast, infinitely varied store of knowledge and wisdom which the human race has accumulated and preserved, pride, even in its most innocent forms, is chased from the heart by feelings of awe not untinged with sadness. As one surveys the mighty array of sages, saints, historians, scientists, poets and philosophers whose treasures one will never be able to admire – still less enjoy – the brief tenure of our existence here dominates mind and spirit.

Think of all the wonderful tales that have been told, and well told, which you will never know. Think of all the searching inquiries into matters of great consequence which you will never pursue. Think of all the delighting or disturbing ideas that you will never share. Think of the mighty labours which have been accomplished for your service, but of which you will never reap the harvest. But from this melancholy there also comes a calm. The bitter sweets of a pious despair melt into an agreeable sense of compulsory resignation from which we turn with renewed zest to the lighter vanities of life.

'What shall I do with all my books?' was the question; and the answer, 'Read them,' sobered the questioner. But if you cannot read them, at any rate handle them and, as it were, fondle them. Peer into them. Let them fall open where they

will. Read on from the first sentence that arrests the eye. Then turn to another. Make a voyage of discovery, taking soundings of uncharted seas. Set them back on their shelves with your own hands. Arrange them on your own plan, so that if you do not know what is in them, you at least know where they are. If they cannot be your friends, let them at any rate be your acquaintances. If they cannot enter the circle of your life, do not deny them at least a nod of recognition.

It is a mistake to read too many good books when quite young. A man once told me that he had read all the books that mattered. Cross-questioned, he appeared to have read a great many, but they seemed to have made only a slight impression. How many had he understood? How many had entered into his mental composition? How many had been hammered on the anvils of his mind, and afterwards ranged in an armoury of bright weapons ready to hand? It is a great pity to read a book too soon in life. The first impression is the one that counts; and if it is a slight one, it may be all that can be hoped for. A later and second perusal may recoil from a surface already hardened by premature contact. Young people should be careful in their reading, as old people in eating their food. They should not eat too much. They should chew it well.

Since change is an essential element in diversion of all kinds, it is naturally more restful and refreshing to read in a different language from that in which one's ordinary daily work is done. To have a second language at your disposal, even if you only know it enough to read it with pleasure, is a sensible advantage. Our educationists are too often anxious to teach children so many different languages that they never get far enough in any one to derive any use or

enjoyment from their study. The boy learns enough Latin to detest it; enough Greek to pass an examination; enough French to get from Calais to Paris; enough German to exhibit a diploma; enough Spanish or Italian to tell which is which; but not enough of any to secure the enormous boon of access to a second literature. Choose well, choose wisely, and choose one. Concentrate upon that one. Do not be content until you find yourself reading in it with real enjoyment. The process of reading for pleasure in another language rests the mental muscles; it enlivens the mind by a different sequence and emphasis of ideas. The mere form of speech excites the activity of separate brain cells, relieving in the most effective manner the fatigue of those in hackneyed use. One may imagine that a man who blew the trumpet for his living would be glad to play the violin for his amusement. So it is with reading in another language than your own.

But reading and book-love in all their forms suffer from one serious defect: they are too nearly akin to the ordinary daily round of the brain-worker to give that element of change and contrast essential to real relief. To restore psychic equilibrium we should call into use those parts of the mind which direct both eye and hand. Many men have found great advantage in practising a handicraft for pleasure. Joinery, chemistry, book-binding, even brick-laying – if one were interested in them and skilful at them – would give a real relief to the over-tired brain. But, best of all and easiest to procure are sketching and painting in all their forms. I consider myself very lucky that late in life I have been able to develop this new taste and pastime. Painting came to my rescue in a most trying time, and I shall venture in the pages that follow to express the gratitude I feel.

Painting is a companion with whom one may hope to walk a great part of life's journey:

Age cannot wither her nor custom stale
Her infinite variety.

One by one the more vigorous sports and exacting games fall away. Exceptional exertions are purchased only by a more pronounced and more prolonged fatigue. Muscles may relax, and feet and hands slow down; the nerve of youth and manhood may become less trusty. But painting is a friend who makes no undue demands, excites to no exhausting pursuits, keeps faithful pace even with feeble steps, and holds her canvas as a screen between us and the envious eyes of Time or the surly advance of Decrepitude. Happy are the painters, for they shall not be lonely. Light and colour, peace and hope, will keep them company to the end, or almost to the end, of the day.

To have reached the age of forty without ever handling a brush or fiddling with a pencil, to have regarded with mature eye the painting of pictures of any kind as a mystery, to have stood agape before the chalk of the pavement artist, and then suddenly to find oneself plunged in the middle of a new and intense form of interest and action with paints and palettes and canvasses, and not to be discouraged by results, is an astonishing and enriching experience. I hope it may be shared by others. I should be glad if these lines induced others to try the experiment which I have tried, and if some at least were to find themselves dowered with an absorbing new amusement delightful to themselves, and at any rate not violently harmful to man or beast.

I hope this is modest enough: because there is no subject on which I feel more humble or yet at the same time more natural. I do not presume to explain how to paint, but only how to get enjoyment. Do not turn the superior eye of critical passivity upon these efforts. Buy a paint-box and have a try. If you need something to occupy your leisure, to divert your mind from the daily round, to illuminate your holidays, do not be too ready to believe that you cannot find what you want here. Even at the advanced age of forty! It would be a sad pity to shuffle or scramble along through one's playtime with golf and bridge, pottering, loitering, shifting from one heel to the other, wondering what on earth to do – as perhaps is the fate of some unhappy beings – when all the while, if you only knew, there is close at hand a wonderful new world of thought and craft, a sunlit garden gleaming with light and colour of which you have the key in your waistcoat pocket. Inexpensive independence, a mobile and perennial pleasure apparatus, new mental food and exercise, the old harmonies and symmetries in an entirely different language, an added interest to every common scene, an occupation for every idle hour, an unceasing voyage of entrancing discovery – these are high prizes. Make quite sure they are not yours. After all, if you try, and fail, there is not much harm done. The nursery will grab what the studio has rejected. And then you can always go out and kill some animal, humiliate some rival on the links, or despoil some friend across the green table. You will not be worse off in any way. In fact you will be better off. You will know 'beyond a peradventure', to quote a phrase disagreeably reminiscent, that that is really what you were meant to do in your hours of relaxation.

But if, on the contrary, you are inclined – late in life though it be – to reconnoitre a foreign sphere of limitless extent, then be persuaded that the first quality that is needed is Audacity. There really is no time for the deliberate approach. Two years of drawing lessons, three years of copying wood-cuts, five years of plaster casts – these are for the young. They have enough to bear. And this thorough grounding is for those who, hearing the call in the morning of their days, are able to make painting their paramount lifelong vocation. The truth and beauty of line and form, which by the slight-est touch or twist of the brush a real artist imparts to every feature of his design, must be founded on long, hard, perse-vering apprenticeship and a practice so habitual that it has become instinctive. We must not be too ambitious. We can-not aspire to masterpieces. We may content ourselves with a joy ride in a paint-box. And for this Audacity is the only ticket.

I shall now relate my personal experience. When I left the Admiralty at the end of May 1915, I still remained a member of the Cabinet and of the War Council. In this pos-ition I knew everything and could do nothing. The change from the intense executive activities of each day's work at the Admiralty to the narrowly measured duties of a coun-sellor left me gasping. Like a sea-beast fished up from the depths, or a diver too suddenly hoisted, my veins threatened to burst from the fall in pressure. I had great anxiety and no means of relieving it; I had vehement convictions and small power to give effect to them. I had to watch the unhappy casting-away of great opportunities, and the feeble execu-tion of plans which I had launched and in which I heartily believed. I had long hours of utterly unwonted leisure in

which to contemplate the frightful unfolding of the war. At a moment when every fibre of my being was inflamed to action, I was forced to remain a spectator of the tragedy, placed cruelly in a front seat. And then it was that the Muse of Painting came to my rescue – out of charity and out of chivalry, because after all she had nothing to do with me – and said, 'Are these toys any good to you? They amuse some people.' Some experiments one Sunday in the country with the children's paint-box led me to procure the next morning a complete outfit for painting in oils.

Having bought the colours, an easel, and a canvas, the next step was *to begin*. But what a step to take! The palette gleamed with beads of colour; fair and white rose the canvas; the empty brush hung poised, heavy with destiny, irreso-lute in the air. My hand seemed arrested by a silent veto. But after all the sky on this occasion was unquestionably blue, and a pale blue at that. There could be no doubt that blue paint mixed with white should be put on the top part of the canvas. One really does not need to have had an artist's training to see that. It is a starting-point open to all. So very gingerly I mixed a little blue paint on the palette with a very small brush, and then with infinite precaution made a mark about as big as a bean upon the affronted snow-white shield. It was a challenge, a deliberate challenge; but so subdued, so halting, indeed so cataleptic, that it deserved no response. At that moment the loud approaching sound of a motor car was heard in the drive. From this chariot there stepped swiftly and lightly none other than the gifted wife of Sir John Lavery. 'Painting! But what are you hesitating about? Let me have a brush – the big one.' Splash into the turpentine, wallop into the blue and the white, frantic flourish on the palette – clean

no longer – and then several large, fierce strokes and slashes of blue on the absolutely cowering canvas. Anyone could see that it could not hit back. No evil fate avenged the jaunty violence. The canvas grinned in helplessness before me. The spell was broken. The sickly inhibitions rolled away. I seized the largest brush and fell upon my victim with berserk fury. I have never felt any awe of a canvas since.

Everyone knows the feelings with which one stands shivering on a springboard, the shock when a friendly foe steals up behind and hurls you into the flood, and the ardent glow which thrills you as you emerge breathless from the plunge. This beginning with Audacity, or being thrown into the middle of it, is already a very great part of the art of painting. But there is more in it than that.

La peinture à l'huile
Est bien difficile,
Mais c'est beaucoup plus beau
Que la peinture à l'eau.

I write no word in disparagement of watercolours. But there really is nothing like oils. You have a medium at your disposal which offers real power, if you only can find out how to use it. Moreover, it is easier to get a certain distance along the road by its means than by watercolour. First of all, you can correct mistakes much more easily. One sweep of the palette-knife 'lifts' the blood and tears of a morning from the canvas and enables a fresh start to be made; indeed the canvas is all the better for past impressions. Secondly, you can approach your problem from any direction. You need not build downwards awkwardly from white paper to your

darkest dark. You may strike where you please, beginning if you will with a moderate central arrangement of middle tones, and then hurling in the extremes when the psychological moment comes. Lastly, the pigment itself is such nice stuff to handle (if it does not retaliate). You can build it on layer after layer if you like. You can keep on experimenting. You can change your plan to meet the exigencies of time or weather. And always remember you can scrape it all away.

Just to paint is great fun. The colours are lovely to look at and delicious to squeeze out. Matching them, however crudely, with what you see is fascinating and absolutely absorbing. Try it if you have not done so – before you die. As one slowly begins to escape from the difficulties of choosing the right colours and laying them on in the right places and in the right way, wider considerations come into view. One begins to see, for instance, that painting a picture is like fighting a battle; and trying to paint a picture is, I suppose, like trying to fight a battle. It is, if anything, more exciting than fighting it successfully. But the principle is the same. It is the same kind of problem as unfolding a long, sustained, interlocked argument. It is a proposition which, whether of few or numberless parts, is commanded by a single unity of conception. And we think – though I cannot tell – that painting a great picture must require an intellect on the grand scale. There must be that all-embracing view which presents the beginning and the end, the whole and each part, as one instantaneous impression retentively and untiringly held in the mind. When we look at the larger Turners – canvasses yards wide and tall – and observe that they are all done in one piece and represent one single second of time, and that every innumerable detail, however small, however distant,

however subordinate, is set forth naturally and in its true proportion and relation, without effort, without failure, we must feel in the presence of an intellectual manifestation the equal in quality and intensity of the finest achievements of warlike action, of forensic argument, or of scientific or philosophical adjudication.

In all battles two things are usually required of the Commander-in-Chief: to make a good plan for his army and, secondly, to keep a strong reserve. Both these are also obligatory upon the painter. To make a plan, thorough reconnaissance of the country where the battle is to be fought is needed. Its fields, its mountains, its rivers, its bridges, its trees, its flowers, its atmosphere – all require and repay attentive observation from a special point of view. One is quite astonished to find how many things there are in the landscape, and in every object in it, one never noticed before. And this is a tremendous new pleasure and interest which invests every walk or drive with an added object. So many colours on the hillside, each different in shadow and in sunlight; such brilliant reflections in the pool, each a key lower than what they repeat; such lovely lights gilding or silvering surface or outline, all tinted exquisitely with pale colour, rose, orange, green, or violet. I found myself instinctively as I walked noting the tint and character of a leaf, the dreamy, purple shades of mountains, the exquisite lacery of winter branches, the dim, pale silhouettes of far horizons. And I had lived for over 40 years without ever noticing any of them except in a general way, as one might look at a crowd and say, 'What a lot of people!'

I think this heightened sense of observation of Nature is one of the chief delights that have come to me through

trying to paint. No doubt many people who are lovers of art have acquired it in a high degree without actually practising. But I expect that nothing will make one observe more quickly or more thoroughly than having to face the difficulty of representing the thing observed. And mind you, if you do observe accurately and with refinement, and if you do record what you have seen with tolerable correspondence, the result follows on the canvas with startling obedience. Even if only four or five main features are seized and truly recorded, these by themselves will carry a lot of ill-success or half-success. Answer five big questions out of all the hundreds in the examination paper correctly and well and, though you may not win a prize, at any rate you will not be absolutely ploughed.

But in order to make his plan, the general must not only reconnoitre the battleground, he must also study the achievements of the great captains of the past. He must bring the observations he has collected in the field into comparison with the treatment of similar incidents by famous chiefs. Then the galleries of Europe take on a new – and to me at least a severely practical – interest. 'This, then, is how —— painted a cataract. Exactly, and there is that same light I noticed last week in the waterfall at ——.' And so on. You see the difficulty that baffled you yesterday; and you see how easily it has been overcome by a great or even by a skilful painter. Not only is your observation of Nature sensibly improved and developed, but you look at the masterpieces of art with an analysing and a comprehending eye.

The whole world is open with all its treasures. The simplest objects have their beauty. Every garden presents innumerable fascinating problems. Every land, every parish, has

its own tale to tell. And there are many lands differing from each other in countless ways, and each presenting delicious variants of colour, light, form, and definition. Obviously, then, armed with a paint-box, one cannot be bored, one cannot be left at a loose end, one cannot 'have several days on one's hands'. Good gracious! what there is to admire and how little time there is to see it in! For the first time one begins to envy Methuselah. No doubt he made a very indifferent use of his opportunities.

But it is in the use and withholding of their reserves that the great commanders have generally excelled. After all, when once the last reserve has been thrown in, the commander's part is played. If that does not win the battle, he has nothing else to give. The event must be left to luck and to the fighting troops. But these last, in the absence of high direction, are apt to get into sad confusion, all mixed together in a nasty mess, without order or plan – and consequently without effect. Mere masses count no more. The largest brush, the brightest colours, cannot even make an impression. The pictorial battlefield becomes a sea of mud mercifully veiled by the fog of war. It is evident there has been a serious defeat. Even though the general plunges in himself and emerges bespattered, as he sometimes does, he will not retrieve the day.

In painting, the reserves consist in Proportion or Relation. And it is here that the art of the painter marches along the road which is traversed by all the greatest harmonies in thought. At one side of the palette there is white, at the other black; and neither is ever used 'neat'. Between these two rigid limits all the action must lie, all the power required must be generated. Black and white themselves, placed in

juxtaposition, make no great impression; and yet they are the most that you can do in pure contrast. It is wonderful – after one has tried and failed often – to see how easily and surely the true artist is able to produce every effect of light and shade, of sunshine and shadow, of distance or nearness, simply by expressing justly the relations between the different planes and surfaces with which he is dealing. We think that this is founded upon a sense of proportion, trained no doubt by practice, but which in its essence is a frigid manifestation of mental power and size. We think that the same mind's eye that can justly survey and appraise and prescribe beforehand the values of a truly great picture in one all-embracing regard, in one flash of simultaneous and homogeneous comprehension, would also with a certain acquaintance with the special technique be able to pronounce with sureness upon any other high activity of the human intellect. This was certainly true of the great Italians.

I have written in this way to show how varied are the delights which may be gained by those who enter hopefully and thoughtfully upon the pathway of painting; how enriched they will be in their daily vision, how fortified in their independence, how happy in their leisure. Whether you feel that your soul is pleased by the conception or contemplation of harmonies, or that your mind is stimulated by the aspect of magnificent problems, or whether you are content to find fun in trying to observe and depict the jolly things you see, the vistas of possibility are limited only by the shortness of life. Every day you may make progress. Every step may be fruitful. Yet there will stretch out before you an ever-lengthening, ever-ascending, ever-improving path. You know you will never get to the end of the journey. But this,

so far from discouraging, only adds to the joy and glory of the climb.

Try it, then, before it is too late and before you mock at me. Try it while there is time to overcome the preliminary difficulties. Learn enough of the language in your prime to open this new literature to your age. Plant a garden in which you can sit when digging days are done. It may be only a small garden, but you will see it grow. Year by year it will bloom and ripen. Year by year it will be better cultivated. The weeds will be cast out. The fruit trees will be pruned and trained. The flowers will bloom in more beautiful combinations. There will be sunshine there even in the wintertime, and cool shade, and the play of shadow on the pathway in the shining days of June.

I must say I like bright colours. I agree with Ruskin in his denunciation of that school of painting who 'eat slate pencil and chalk, and assure everybody that they are nicer and purer than strawberries and plums'. I cannot pretend to feel impartial about the colours. I rejoice with the brilliant ones, and am genuinely sorry for the poor browns. When I get to heaven I mean to spend a considerable portion of my first million years in painting, and so get to the bottom of the subject. But then I shall require a still gayer palette than I get here below. I expect orange and vermilion will be the darkest, dullest colours upon it, and beyond them there will be a whole range of wonderful new colours which will delight the celestial eye.

Chance led me one autumn to a secluded nook on the Côte d'Azur, between Marseilles and Toulon, and there I fell in with one or two painters who revelled in the methods of the modern French school. These were disciples of Cézanne.

They view Nature as a mass of shimmering light in which forms and surfaces are comparatively unimportant, indeed hardly visible, but which gleams and glows with beautiful harmonies and contrasts of colour. Certainly it was of great interest to me to come suddenly in contact with this entirely different way of looking at things. I had hitherto painted the sea flat, with long, smooth strokes of mixed pigment in which the tints varied only by gradations. Now I must try to represent it by innumerable small separate lozenge-shaped points and patches of colour – often pure colour – so that it looked more like a tessellated pavement than a marine picture. It sounds curious. All the same, do not be in a hurry to reject the method. Go back a few yards and survey the result. Each of these little points of colour is now playing his part in the general effect. Individually invisible, he sets up a strong radiation, of which the eye is conscious without detecting the cause. Look also at the blue of the Mediterranean. How can you depict and record it? Certainly not by any single colour that was ever manufactured. The only way in which that luminous intensity of blue can be simulated is by this multitude of tiny points of varied colour all in true relation to the rest of the scheme. Difficult? Fascinating!

Nature presents itself to the eye through the agency of these individual points of light, each of which sets up the vibrations peculiar to its colour. The brilliancy of a picture must therefore depend partly upon the frequency with which these points are found on any given area of the canvas, and partly on their just relation to one another. Ruskin says in his *Elements of Drawing*, from which I have already quoted, 'You will not, in Turner's largest oil pictures, perhaps six or

seven feet long by four or five high, find one spot of colour as large as a grain of wheat ungraded.' But the gradations of Turner differ from those of the modern French school by being gently and almost imperceptibly evolved one from another instead of being bodily and even roughly separated; and the brush of Turner followed the form of the objects he depicted, while our French friends often seem to take a pride in directly opposing it. For instance, they would prefer to paint a sea with up and down strokes rather than with horizontal; or a tree trunk from right to left rather than up and down. This, I expect, is due to falling in love with one's theories, and making sacrifices of truth to them in order to demonstrate fidelity and admiration.

But surely we owe a debt to those who have so wonderfully vivified, brightened and illuminated modern landscape painting. Have not Manet and Monet, Cézanne and Matisse, rendered to painting something of the same service which Keats and Shelley gave to poetry after the solemn and ceremonious literary perfections of the eighteenth century? They have brought back to the pictorial art a new draught of *joie de vivre*; and the beauty of their work is instinct with gaiety, and floats in sparkling air. I do not expect these masters would particularly appreciate my defence, but I must avow an increasing attraction to their work. Lucid and exact expression is one of the characteristics of the French mind. The French language has been made the instrument of the admirable gift. Frenchmen talk and write just as well about painting as they have done about love, about war, about diplomacy, or cooking. Their terminology is precise and complete. They are therefore admirably equipped to be teachers in the theory of any of these arts. Their critical faculty is so

powerfully developed that it is perhaps some restraint upon achievement. But it is a wonderful corrective to others as well as to themselves.

My French friend, for instance, after looking at some of my daubs, took me round the galleries of Paris, pausing here and there. Wherever he paused, I found myself before a picture which I particularly admired. He then explained that it was quite easy to tell, from the kind of things I had been trying to do, what were the things I liked. Never having taken any interest in pictures till I tried to paint, I had no preconceived opinions. I just felt, for reasons I could not fathom, that I liked some much more than others. I was astonished that anyone else should, on the most cursory observation of my work, be able so surely to divine a taste which I had never consciously formed. My friend said that it is not a bad thing to know nothing at all about pictures, but to have a matured mind trained in other things and a new strong interest for painting. The elements are there from which a true taste in art can be formed with time and guidance, and there are no obstacles or imperfect conceptions in the way. I hope this is true. Certainly the last part is true.

Once you begin to study it, all Nature is equally interesting and equally charged with beauty. I was shown a picture by Cézanne of a blank wall of a house, which he had made instinct with the most delicate lights and colours. Now I often amuse myself when I am looking at a wall or a flat surface of any kind by trying to distinguish all the different colours and tints which can be discerned upon it, and considering whether these arise from reflections or from natural hue. You would be astonished the first time you tried this to see how many and what beautiful colours there are even in

the most commonplace objects, and the more carefully and frequently you look the more variations do you perceive.

But these are no reasons for limiting oneself to the plainest and most ordinary objects and scenes. Mere prettiness of scene, to be sure, is not needed for a beautiful picture. In fact, artificially-made pretty places are very often a hindrance to a good picture. Nature will hardly stand a double process of beautification: one layer of idealism on top of another is too much of a good thing. But a vivid scene, a brilliant atmosphere, novel and charming lights, impressive contrasts, if they strike the eye all at once, arouse an interest and an ardour which will certainly be reflected in the work which you try to do, and will make it seem easier.

It would be interesting if some real authority investigated carefully the part which memory plays in painting. We look at the object with an intent regard, then at the palette, and thirdly at the canvas. The canvas receives a message dispatched usually a few seconds before from the natural object. But it has come through a post office *en route*. It has been transmitted in code. It has been turned from light into paint. It reaches the canvas a cryptogram. Not until it has been placed in its correct relation to everything else that is on the canvas can it be deciphered, is its meaning apparent, is it translated once again from mere pigment into light. And the light this time is not of Nature but of Art. The whole of this considerable process is carried through on the wings or the wheels of memory. In most cases we think it is the wings – airy and quick like a butterfly from flower to flower. But all heavy traffic and all that has to go a long journey must travel on wheels.

In painting in the open air the sequence of actions is so rapid that the process of translation into and out of pigment

may seem to be unconscious. But all the greatest landscapes have been painted indoors, and often long after the first impressions were gathered. In a dim cellar the Dutch or Italian master recreated the gleaming ice of a Netherlands carnival or the lustrous sunshine of Venice or the Campagna. Here, then, is required a formidable memory of the visual kind. Not only do we develop our powers of observation, but also those of carrying the record – of carrying it through an extraneous medium and of reproducing it, hours, days, or even months after the scene has vanished or the sunlight died.

I was told by a friend that when Whistler guided a school in Paris he made his pupils observe their model on the ground floor, and then run upstairs and paint their picture piece by piece on the floor above. As they became more proficient, he put their easels up a storey higher, till at last the *élite* were scampering with their decision up six flights into the attic – praying it would not evaporate on the way. This is, per- haps, only a tale. But it shows effectively of what enormous importance a trained, accurate, retentive memory must be to an artist; and conversely what a useful exercise painting may be for the development of an accurate and retentive memory.

There is no better exercise for the would-be artist than to study and devour a picture, and then, without looking at it again, to attempt the next day to reproduce it. Nothing can more exactly measure the progress both of observation and memory. It is still harder to compose out of many separate, well-retained impressions, aided though they be by sketches and colour notes, a new, complete conception. But this is the only way in which great landscapes have been painted – or can be painted. The size of the canvas alone precludes its being handled out of doors. The fleeting light imposes a

rigid time limit. The same light never returns. One cannot go back day after day without the picture getting stale. The painter must choose between a rapid impression, fresh and warm and living, but probably deserving only of a short life, and the cold, profound, intense effort of memory, knowledge, and will power, prolonged perhaps for weeks, from which a masterpiece can alone result. It is much better not to fret too much about the latter. Leave to the masters of art trained by a lifetime of devotion the wonderful process of picture-building and picture-creation. Go out into the sunlight and be happy with what you see.

Painting is complete as a distraction. I know of nothing which, without exhausting the body, more entirely absorbs the mind. Whatever the worries of the hour or the threats of the future, once the picture has begun to flow along, there is no room for them in the mental screen. They pass out into shadow and darkness. All one's mental light, such as it is, becomes concentrated on the task. Time stands respectfully aside, and it is only after many hesitations that luncheon knocks gruffly at the door. When I have had to stand up on parade, or even, I regret to say, in church, for half an hour at a time, I have always felt that the erect position is not natural to man, has only been painfully acquired, and is only with fatigue and difficulty maintained. But no one who is fond of painting finds the slightest inconvenience, as long as the interest holds, in standing to paint for three or four hours at a stretch.

Lastly, let me say a word on painting as a spur to travel. There is really nothing like it. Every day and all day is provided with its expedition and its occupation — cheap, attainable, innocent, absorbing, recuperative. The vain racket of

the tourist gives place to the calm enjoyment of the phil-
osopher, intensified by an enthralling sense of action and
endeavour. Every country where the sun shines, and every
district in it, has a theme of its own. The lights, the atmos-
phere, the aspect, the spirit, are all different; but each has its
native charm. Even if you are only a poor painter you can
feel the influence of the scene, guiding your brush, select-
ing the tubes you squeeze on to the palette. Even if you
cannot portray it as you see it, you feel it, you know it, and
you admire it for ever. When people rush about Europe in
the train from one glittering centre of work or pleasure to
another, passing – at enormous expense – through a series
of mammoth hotels and blatant carnivals, they little know
what they are missing, and how cheaply priceless things can
be obtained. The painter wanders and loiters contentedly
from place to place, always on the look-out for some bril-
liant butterfly of a picture which can be caught and set up
and carried safely home.

Now I am learning to like painting even on dull days. But
in my hot youth I demanded sunshine. Sir William Orpen
advised me to visit Avignon on account of its wonderful
light, and certainly there is no more delightful centre for
a would-be painter's activities: then Egypt, fierce and
brilliant, presenting in infinite variety the single triplex
theme of the Nile, the desert, and the sun; or Palestine,
a land of rare beauty – the beauty of the turquoise and
the opal – which well deserves the attention of some real
artist, and has never been portrayed to the extent that is
its due. And what of India? Who has ever interpreted its
lurid splendours? But after all, if only the sun will shine,
one does not need to go beyond one's own country. There

is nothing more intense than the burnished steel and gold of a Highland stream; and at the beginning and close of almost every day the Thames displays to the citizens of London glories and delights which one must travel far to rival.

11.

'BETWEEN TRADITION AND INNOVATION'

Speech to the Royal Academy banquet, Burlington House, London, 30 April 1953

T HE ARTS ARE ESSENTIAL to any complete national life. The nation owes it to itself to sustain and encourage them. The country possesses in the Royal Academy an institution of power and reputation for the purpose of encouraging the arts of painting and sculpture. It would be disastrous if the control of this machine fell into the hands of any particular school of artistic thought, which like a dog in a manger would have little pleasure itself but would exclude all others. The function of such an institution as the Royal Academy is to hold a middle course between tradition and innovation. Without tradition art is a flock of sheep without a shepherd. Without innovation it is a corpse. Innovation of course involves experiment. Experiments may or may not be fruitful. Certainly it is not the function of the Royal Academy to run wildly after novelty. There are many opportunities and many places for experimental artists to try their wings and it is not until the results of their experiments have won a certain measure of acceptance from the general agreement of qualified judges that the Royal Academy can be expected to give them its countenance.

Art and politics. They have two things in common. The first is the controversial difference of opinion between those engaged in them. The controversies in the field of art are at least as vigorous as those in politics. The second is the search for truth. Tireless and impartially successful. About people who go in for novel forms of art. If they have had a thorough grounding and have proved themselves the masters of line and colour they have a right to express themselves. But one views with some suspicion people who have had no sort of artistic training and go in for the most extraordinary performances in the hope of obtaining notoriety and even profit. It is a broad question whether any measure of regimentation is compatible with art. On the whole I find myself on the side of the disciplinarians. Of course one may go too far, but no large organization can continue without a strong element of authority and respect for authority. There must be in any really healthy, effective body a sense of collective security.

12.

'A NEW ELEVATION OF THE MIND'

Speech to the Royal Academy banquet, Burlington House, London, 28 April 1954

I AM VERY MUCH obliged to Sir Gerald Kelly for proposing the toast of Her Majesty's Ministers, and for the compliment which he has paid to me. I cannot help regretting that after what may well have been a prolonged meditation he has not been able to find anything to say about our politics good, bad, or indifferent, but has simply commended us to the natural kindness of this distinguished gathering. A more fertile theme would perhaps have been 'the difficulties of Her Majesty's Ministers', and he could have expatiated on these without in any way giving offence to the Leader of the Opposition [Clement Attlee] whom we are so glad to see here tonight and who, I believe, has his difficulties too.

Sir Gerald has, however, decided to keep clear of politics and politicians as long as they do not send pictures to the Royal Academy, or otherwise trespass upon the domains of art. This prudent course imposes, however, disadvantages upon the politician who is called upon to reply. He is like a painter invited to produce a masterpiece but unprovided with any particular subject wherewith to fill his canvas. He has got to provide it all out of his own head or else embark upon a dreary vindication of conduct which has neither

been impugned or even praised. Sir Gerald need not have restricted himself in this way. Her Majesty's Ministers are quite used to being criticized, and even if they were paid a tribute I am sure Mr Attlee would not have been offended. He is quite used to putting up with things. Let me therefore confine myself to more agreeable topics than politics.

I was very glad when it was decided a few years ago to revive the Royal Academy Banquet after the war, and we are grateful to Sir Alfred Munnings not only for his strong initiative but for the controversial element with which he enlivened the proceedings. It is with genuine regret that we face the fact tonight that this is the last Royal Academy dinner over which Sir Gerald Kelly will preside. The Presidents of the Royal Academy are esteemed figures in British life. None has been more tireless in his search for the welfare of the Academy and of British art in general than Sir Gerald. During his Presidency we have had the Dutch Exhibition and the Flemish Exhibition. Seldom if ever have there been exhibitions at Burlington House which surpassed them either in the quality of the pictures or in the crowds they have attracted. For these remarkable selections of paintings we have Sir Gerald Kelly's personal labours and persistence to thank. His successor will take over the Presidency at a high level of popularity and acclaim.

Last year I spoke of conventional and unconventional art, and of the controversies and compromises which exist between them. It was with a shock that a few months ago I heard that warfare was now being classified in 'conventional' and 'unconventional' forms and that these had become the official expressions on the continent of Europe. These hitherto harmless, inoffensive terms now strike

a knell in all our hearts. Indeed, we may ask ourselves whether we should go on with the routine, ceremonies and festivities of our daily round when dangers are growing which might end the life of the human race. I have no doubt what the answer is to that question, namely, that the more the human mind is enriched and occupied and the conditions of our life here are improved and our capacities enriched, the greater is the chance that the unconventional weapons will lead not to general annihilation but to that outlawry of war which generation after generation has sought in vain.

In the course of a few bewildering years we have found ourselves the master or indeed the servants of gigantic powers which confront us with problems never known before. It may be that our perils may prove our salvation. If so this will depend upon a new elevation of the mind of man which will render him worthy of the secrets he has wrested from nature. In this transfiguration the arts have a noble and vital part to play. We therefore have no need to reproach ourselves for levity in coming here tonight.

PART TWO

On Churchill's Art

1.

'PAINTING A PICTURE IS LIKE FIGHTING A BATTLE'

Eric Newton

1950

WHATEVER MR CHURCHILL DOES is done thoroughly. Whether he is marshalling armies or Cabinet ministers or words or paint-brushes he combines intelligence, foresight and will power to a degree that makes him impossible to ignore. He knows what he wants to do; he is certain of what he wants to say. What he does is done with energy and what he says is said with clarity. It follows that an essay by Mr Churchill about a hobby of Mr Churchill's is well worth reading. And when the moral of the essay is, in effect, 'Go thou and do likewise,' a great many people, admiring his achievements and bewitched by his persuasiveness, will try to follow in his footsteps; and some of them will be surprised to find themselves stumbling where he walked with ease. This essay was written in 1932 [sic], but it is as appropriate to today's problems as when it was written. It is a passionately worded plea to the ordinary busy, worried man to take up painting as a hobby, not in order to discover his own latent artistic genius but because he will thereby distract his mind from his normal

worries and call into play an entirely different set of 'mental muscles'. The practice of painting, from this point of view, sounds very much like a kind of therapy. But 'paint for your mental health's sake' is not an adequate summing up of Mr Churchill's message.

Briefly he describes his problem – the urgent necessity to escape from the absorbing burdens of statesmanship, not by relaxing or retiring from the world but by selecting an entirely different but equally absorbing occupation. Reading is no use: it makes no demands on the creative imagination, nor does it involve the patient in that delightful struggle with a tangible medium that only the arts of painting and carving can supply. Having decided to paint, Mr Churchill plunges in at the deep end ('Be persuaded that the first quality that is needed is audacity. There really is no time for the deliberate approach'), and drags his reader with him. With delightful naiveté he explains the beginnings, not of intellectual interest but of physical joy. Did I say his qualifications were intelligence, foresight and will power? I should have added 'a capacity for enthusiasm'. Once he has taken the plunge he becomes a schoolboy. 'Just to paint is great fun. The colours are lovely to look at and delicious to squeeze out.' But he is also a general. 'One begins to see that painting a picture is like fighting a battle.'

I particularly like 'One begins to see.' He has crossed the frontier into unknown country, carrying his immense adventurer's equipment with him. Even so might a professional Arctic explorer say: 'One begins to see that Central Africa also has its points of interest.' The essay proceeds. Military metaphors take charge. 'The general must not only reconnoitre the battleground: he must also study the

achievement of the great captains of the past... Then the galleries of Europe take on a new – and to me, at least, a severely practical – interest.' By what plan of campaign did Turner win his victories? What were Titian's tactics? How did Vélasquez dispose of his reserves? Can I adapt Cézanne's strategy to my own campaign? One can imagine the alert Churchillian mind posing such problems and the restless Churchillian hand trying out the answers on the battle-field of each virgin canvas. And with each little successful skirmish (Mr Churchill is humble enough not to claim for himself a series of major victories) he becomes more enthusiastic, more certain of success and more conscious of what painting has done for him.

This essay, then, is his own little manual of painterly tactics. It is also an expression of gratitude to the hobby that has taught him so much because he was, and still is, willing to learn so much, and because he is, by temperament, capable of learning so much. For that reason it is an admirable introduction to the subject. Its title explains it. It makes no attempt to refer to painting as an expression of man's immortal soul. It contents itself with asserting that when a man's life is overburdened and circumscribed by urgent duties and heavy responsibilities, he can shed his burdens and enlarge his horizon – if only he will take the trouble to translate the beauties of the world in which he lives into paint. He will begin to discover beauties he had never suspected and to develop a craftsmanship that can be endlessly perfected. 'For the first time one begins to envy Methusaleh.' That sentence includes the whole of the Churchillian self-confidence and the Churchillian humility.

The book contains eighteen colour reproductions of Mr Churchill's paintings. This brief review of what Mr Churchill has written is not the proper place for an art critic's estimate of what he has painted. But each one of the plates is a solid proof that every word in the essay is serious. No man who was not in furious earnest could paint as competently as this. Churchill's subjects range from still life and landscape in Kent to Mediterranean coast scenes and sunlit olive groves in southern France. They are gay and vivid, but they are far more than mere attempts to capture the bright picturesque surface. Painting has taught him to see. 'The vain racket of the tourist gives place to the calm enjoyment of the philosopher,' he wisely remarks, and then characteristically adds, 'intensified by an enthralling sense of action and endeavour.' How typical that is! Having written the words 'calm' and 'philosopher' he looks at them with vague unease. The schoolboy and the general in him whisper into his ear 'action' and 'endeavour'. He grins, takes another pull at his cigar, and adds the operative phrase.

2.

'UNITY, VITALITY, INFINITY AND REPOSE'

Thomas Bodkin

1953

To APPRAISE SIR WINSTON Churchill's abilities as an artist-painter, and to assess accurately the value, aesthetic or monetary, of his pictures, is a task which none of his contemporaries can set about hopefully. The critic must be prejudiced, one way or another, by the knowledge that the man who produced these pictures has amply proved himself to be the possessor of genius as a statesman, as a historian and as an orator. He is, very probably, the most remarkable Englishman who has ever lived, and likely to remain for ages the most admired of Englishmen in the eyes of other races. If he chooses to spend much of his scanty leisure in painting, surely it must be assumed that he is intelligent enough to know that such time is well spent, and that he would have sufficient power of self-criticism to refrain from preserving with care, and some pride, the results of his efforts should these prove to be of negligible worth.

It is all very well to ask the critic: what would you think of his pictures if you came suddenly upon a large number of them, unsigned and untitled, for the first time in a public exhibition? A competent critic would, beyond all shadow of doubt, reply at least that he would be much

impressed by them and would want to see that exhibition again, fortified by some outside knowledge of the painter's personality and career. Good work in any art provokes curiosity about its author. To assert that knowledge of an artist's life is irrelevant to the judgment of his art is an affectation, often indulged, but one which runs counter to experience. The more we know about his antecedents, his environment, his ambitions, his fortunes, his family and his physical and intellectual equipment, the more likely we are to understand whatever he may be trying to say to us in the language of his art, be that a language made of words, of sounds, or of visual images. That is the fundamental reason why we welcome with enthusiasm all new information that may be discovered about the lives and personalities of the great artists of the past, and use it to throw light on their achievements.

Knowing a great deal about Sir Winston Churchill as a man, we expect to find his salient qualities reflected in his painting. We are not disappointed in this expectation. A striking characteristic of his pictures is their quite extraordinary decisiveness. Each is a clear and forcible pronouncement. He does not niggle nor retouch. His paint is laid once and for all with no apparent hesitation or afterthought. It is never fumbled or woolly in texture. Spaces are filled with obvious speed. His colours are bright, clean and well harmonized. His drawing makes factual statements, though these may not always be quite accurate in detail. His knowledge of perspective, for example, is far from being that of a well-trained and practised professional artist. Sometimes the façade of a building, standing at an angle to the horizon, will seem to spread open rather than contract as it recedes from the eye

of the beholder. Reflections shown in water will not always chime in correct alignment with the objects reflected. But were he more scientific, it is likely that he would lose some of the spontaneity which is one of his most potent attractions. His inaccuracies are never of substantial importance.

His ability to devise a good composition might well be envied by many a successful modern professional. He does not try to say two or more things at the same time. Each of his pictures is the presentation of a distinct theme: a tower, a village, a church, a lake, a harbour, a range of mountains, a pool, a group of palm trees, an English grove, a Grecian temple. The dominant motive is never obscured by irrelevancies. The spectator's eye is never tempted to wander outside the confines of the frame. This power to design well is one which may be developed by attention to rules and formulae. But in his case there seems to be an inherent natural ability in action, without much planning or preoccupation, which brings about results that wear a delightful air of improvisation.

The range of subjects that appeal to him is also very remarkable; and he is never repetitive. When he brings off a convincing effect he shows no desire to continue in the same strain; and his next picture is apt to be concerned with some quite different problem. He is primarily interested in landscape, but shows no desire to subject natural appearances to romantic or dramatic conventions. He does not attempt to deal with storms, night-scenes or, even, lurid sunsets. Light and peace, those qualities which all wise men most value in life, are indubitably those which chiefly distinguish the scenes that he prefers to paint.

'Escapism' is a word that has sometimes been used to describe Sir Winston's attitude to pictorial art. It is an ugly

word, often carrying a sense of denigration. Yet the function of art, alike for those who produce it as for those who enjoy it, is primarily to release the human spirit from the undue pressure of mundane affairs, or to shield it from the more sordid aspects of reality. The Greeks and the Florentines, each in their Golden Age, lived amid lovely surroundings and knew nothing of the grim horrors of total war or mass manufacture. Their art was, therefore, principally centred on the human body portrayed in postures carefully calculated to enhance mankind's normal ideals of dignity and power. The vast population of modern Europe and America must, for the most part, live in densely overcrowded cities, dark with smoke and throbbing with ceaseless noise. They long for the quiet of green fields and clean skies; and so the art of the landscape painter is the one which best fulfils their spiritual need. It was a branch of art that only existed precariously and in a subsidiary way a few centuries ago. Now it has out-grown all the others. Landscape predominates in every con-temporary exhibition of pictures.

Sir Winston cannot avoid being a man of his period. His long working life has been largely spent under the urgent pressure of public business and in contact with innumerable people. Naturally when he first took seriously to oil painting, after he had passed his fortieth year, it was to landscape that he looked for inspiration.

He himself has told the story of his beginnings in an art-icle entitled 'Painting as a Pastime', which appeared in the *Strand* magazine and was reprinted soon afterwards in his book *Thoughts and Adventures*, published in 1932. That article, amplified, forms a large part of the persuasive lively book, also entitled *Painting as a Pastime*, which came out in 1948

and has been selling steadily ever since. Its call to Everyman to paint for himself, reinforced by good coloured reproductions from sixteen well selected pictures by its author, must have powerfully stimulated the sale of artists' materials during the past five of his work. Truth is the daughter of Time. At the moment all that can be safely conjectured is that the association value preponderates. The painter himself is singularly modest in speaking persistently of his painting as a mere pastime. He goes too far towards suggesting that there is a great gulf fixed between what he calls 'the real artist', highly trained, and the man who paints for pleasure, largely by rule of thumb, when he can find time to do so amid more pressing pursuits. There have been masters of the first rank who painted as instinctively as a bird sings and needed little tuition. Corot was one of these.

Sir Winston Churchill himself is another instinctive painter, though one who is always searching for fresh ways and means to produce the desired results. Madame Balsan has described him painting the moat at her country house in France. He decided that the still water did not contribute to the effect he sought. So a boat was moored to the bank in order that an oarsman therein might churn up ripples on its surface. Finally, a photographer was called in to record their pattern for future reference. Photographs have also been used as aids to the drawing and placing of some of the rare figures in Sir Winston's landscapes. The purist may object to this, though Degas is known to have learned much from photographs, and Sickert relied on them with increasing frequency throughout his life, and never hesitated to acknowledge his debt.

Chesterton, on hearing someone described as a 'minor poet', took hot exception to the term, insisting that the

significant word was 'poet', and that the word 'minor' was an uncalled-for disparagement. By analogy Sir Winston as a painter should be described comprehensively as an artist. No one, least of all himself, wishes to describe him as a Master. In a wise, learned and, unfortunately, half-forgotten book, *The Science of Picture-Making*, the late Sir Charles Holmes postulated that all pictures should possess the qualities of unity, vitality, infinity and repose. All these, in varying degrees, seem to be present in Sir Winston's pictures. Another quality which, to my mind, should characterize a true work of art is inexhaustibility. The melody, the poem, or the picture should exist as a fountain that flows always or a fire that never dies, to which a man may return hopefully whenever he needs refreshment or enlightenment. It is precisely that strange quality which transmutes verses into poems, and paintings into pictures. Sir Winston's paintings often possess it. As I write, there comes to my mind a tall canvas on which he has shown a long perspective of the golden walls of the city of Marrakesh soaked in tropical sunlight, and sentinelled by a rank of slender, green-crested palm trees. In the lower left-hand corner three erect, dark, motionless figures are standing in a mysterious group. It is one of those many pictures of his which, I think, any wise man would wish to contemplate again and again.

3.

'GAY, BRILLIANTLY COLOURED CANVASSES'

John Rothenstein

1954

'TO KNOW A PAINTER,' said Delacroix after a visit to Corot, 'you must see him in his studio.' It was on 21 February 1949 that I was first accorded the privilege of thus visiting Sir Winston Churchill. When I arrived at Chartwell no car stood in front of the house, and from the hall no sound was to be heard. Upon a table reposed an object familiar from innumerable photographs: a wide-brimmed, grey painting hat. I was contemplating this celebrated object with respect, as though it were the hat of a king sent to represent him on some ceremonial occasion, when I heard soft padding steps approach, and presently, dressed in his sky-blue siren-suit and shod in soft black slippers on which his initials were worked in gold, there appeared my host benignly welcoming.

Before lunch we visited his studio, a long, narrow room brightly lit by high windows along two walls. Upon a long, narrow table standing lengthwise to the room were ranged tidy rows of paint tubes; beside it was the great terrestrial globe, a present, he told me, from the American army. But for this globe, there was throughout the whole house a conspicuous absence of any display of trophies, historic battle orders and the

like. The suggestion was made some years ago that Chartwell should one day be preserved as a museum. If it were left in its present state there would be little to remind the visitor of the fabulous career of its former owner, and filled with trophies it would give a false impression of his manner of living.

During our first visit to his studio Churchill told me that he would be grateful for any criticism of his painting I might care to make. 'Speak, I pray, with absolute frankness,' he urged as we went to lunch. As soon as we sat down he began to speak of Sickert: 'He came to stay here and in a fortnight he imparted to me all his considered wisdom about painting. He had a room specially darkened to work in, but I wasn't an apt pupil, for I rejoice in the highest lights and the brightest colours.' He spoke with appreciation of Sickert's knowledge of music halls, and he sang a nineteenth-century ballad he had learnt from him; and he sang it from beginning to end. 'I think the person who taught me most about painting was William Nicholson. I noticed you looking, I thought with admiration, at the drawings upstairs he made of my beloved cat.' During lunch his most memorable remark did not concern painters or painting. Upon his inquiring why I declined his offer of a cigar, I replied that every man should possess one virtue; the only one I could certainly claim was that I did not smoke: to which he instantly rejoined, 'There is no such thing as a negative virtue. If I have been of any service to my fellow men, it has never been by self-repression, but always by self-expression.' Back in the studio, fortified by a bottle of champagne, his invitation to give my opinion of his work without reserve seemed to me less alarming. In the course of the afternoon we must have looked at every one of the

numerous paintings in the studio and the few that hung in various other parts of the house.

Churchill was so genial and so exhilarating a companion that before I had been with him long the notion of speaking with absolute frankness seemed as natural as it had earlier seemed temerarious. My first detailed criticism of one of his paintings had an unexpected, indeed a startling, result. About one of his landscapes – a wood on the margin of a lake – I offered the opinion that the shore was far too shallow, too lightly modelled and far too pale in tone to support the weight of the heavy trees with their dense, dark foliage, so that, instead of growing up out of the earth, they weighed it down. 'Oh,' he said, 'I can put that right at once; it would take less than a quarter of an hour,' and he began to look out the appropriate brushes and colours.

'But this painting, surely,' I said, 'must be among your earliest?'
'I did it about twenty years ago,' he conceded.

'Well then,' I protested, 'surely it's impossible for you to recapture the mood in which you painted it, or indeed your whole outlook of those days?'
'You really are convinced of that,' he grumbled, abandoning the notion of repainting with evident reluctance. This was the first of several occasions when I had to persuade him to desist from repainting an early work in consequence of some criticism of mine. 'If it weren't for painting,' Sir Winston said as we left the studio, 'I couldn't live; I couldn't bear the strain of things.'

The key to the understanding of Churchill's own paint-
ing is to be found, I believe, in a few sentences in his essay,
Painting as a Pastime. These explain the seeming contradic-
tion between the known personality and experience of the
painter, and the character of the work; between the man
profoundly and consistently preoccupied with the affairs of
men, above all in their political and military aspects, and the
small landscapes in which there is nowhere any intimation
of struggle or tragedy, and in which, indeed, man scarcely
figures at all. To many his little, gay, brilliantly coloured
canvasses seem to bear no relation to their creator, but such
people make insufficient allowance for the difficulties of the
art of painting. Had the fairies stuck a paint brush into his
hand instead of a pen into one and a sword into the other,
had he learnt while still a boy to draw and to paint, had he
dedicated an entire laborious lifetime to the tempering of
his powers, and to the disciplining of his visual imagination,
these powers would have been immeasurably greater.

Then he would have been equipped to express a large part
of himself, instead of a few facets. He would have painted big
pictures (it is significant that in his essay he calls pictures
'great' when the context shows that he means 'big'). There
can be little doubt that he would have represented human
beings and their affairs. In fact I recall his exclaiming, on
an earlier occasion when we were looking at 'Napoleon on
the *Bellerophon*', 'I don't see why artists today regard great
themes as less legitimate than trivial ones.' Fully equipped,
he would have been what in the age of Reynolds was called
a 'history' painter. His circumstances were in fact quite dif-
ferent. He was a late starter; he had neither the systematic
training nor the leisure necessary to develop his talents to

the full. He does not undertake heroic themes, large organizations of figures in action – many figures, perhaps, in vigorous action – he does not undertake them because they demand what the circumstances of his public life have denied him: the most expert knowledge and a long daily experience of painting.

Sir Winston's consistent awareness of his limitations is implicit in the sentences which give the key to his work:

The painter must choose between a rapid impression, fresh and warm and living, but probably deserving only of a short life, and the cold, profound, intense effort of memory, knowledge and will-power, prolonged perhaps for weeks, from which a masterpiece can alone result. It is much better not to fret too much about the latter. Leave to the masters of art trained by a lifetime of devotion the wonderful process of picture-building and picture-creation. Go out into the sunlight and be happy with what you see.

This awareness led him to cultivate the possibilities open to him with the utmost assiduity and resource. He is therefore, able to do much more than enjoy himself in the sunlight. The skilful choice of subjects within his range to which he can respond ardently enables him to paint pictures that convey and enhance delight and are distinguished by their painterly qualities; pictures, too, that have an intimate and direct relation to his outlook on life. In these there comes surging irrepressibly up his sheer joy in the simple beauties of nature: water, still, bubbling, or agitated by wind; snow immaculate and crisp; trees, dark

with the density of their foliage or dappled by sunlight; fresh flowers; distant mountains, and, above all, sunlight at its fiercest. The high peaks of his achievement, in my opinion, are 'The Goldfish Pool at Chartwell' (1948), 'The Loup River Québec' (1947), 'Chartwell under Snow' (1947) and 'Cannes Harbour, Evening' (1923). These express, with insight and candour, his exultant enjoyment of living. 'I look forward,' he said, 'to a leisure hour with pleasurable agitation: it's so difficult to choose between writing, reading, painting, bricklaying, and three or four other things I want to do.'

It is relevant, in view of a deliberate attempt to associate the illustrious name of Sir Winston with vulgar attacks upon Picasso, Matisse and other contemporary painters outside the academic fold, to point out that not only does he himself belong to what is likely to be the last phase of Impressionism, but that the expressive violence of the colour in his later pictures shows that he has looked with sympathy at Post-Impressionism as well. The evidence of his painting is reinforced by that of his written tribute to his masters. 'But surely,' he wrote in his essay,

> we owe a debt to those who have so wonderfully vivified, brightened and illuminated modern landscape painting. Have not Manet and Monet, Cézanne and Matisse, rendered to painting something of the same service which Keats and Shelley gave to poetry after the solemn and ceremonious perfections of the eighteenth century? They have brought back to the pictorial art a new draught of *joie de vivre*; and the beauty of their work is instinct with gaiety, and floats in sparkling air.

4.

'LONG MAY HE THRIVE!'

Augustus John

1959

THE LATE JOHN LAVERY used to set aside one day a week for visitors, when he had a studio in South Kensington. On these days he would show such work as he was engaged on to his friends. It was here that I once met Winston Churchill, who, under Lavery's aegis, was giving a show of his own work for the first time. Many of his canvasses were to be seen but, as far as I can remember, no drawings were visible. When on this occasion it came to my turn to pass judgement, I found myself in a quandary. Was I merely to join in the general chorus of applause which, however well merited, seemed to me a little hollow, or should I dare to offer a word of warning to a beginner who, in another capacity, had always shown himself superlatively competent to withstand both criticism and cajolery? Omitting the latter method of persuasion, I chose the harder way.

Much as I appreciated the vigour and dash of the oil sketches, I failed to discover any sign of that patient attention to detail and the structure and proportions of form, which, when a student at the Slade, I had learnt to look for, and find, in the earliest studies of the Masters. My pseudo-academic training, in fact, proved an obstacle rather than an aid to my

immediate recognition of a gifted tyro (as I suppose Winston Churchill could be described at that time) who, in defiance of tradition (but *which* tradition?) had dared to start at the end rather than the beginning of his apprenticeship (if one can apply such a term to a display of masterfulness which shewed as little evidence of labour as of discipline!).

But a glance at the present exhibition convicts me of gross pedantry, ignorance, or worse – a lack of candour. Instead of urging the neophyte to proceed with even greater audacity, freedom and independence of spirit, I had, like an old woman, called for more caution, stricter self-control and closer obser- vance of 'tradition'. In other words, I was advocating the very qualifications which I notoriously lacked myself!

Could this have been a despicable attempt to undermine a talent already too formidable for comfort? Was I, not Winston, the politician on this occasion? It was long ago and I can hardly believe that at so tender an age I could have been capable of duplicity. But whatever my motives, my words were not ill-received. I had at least taken my task ser- iously, and young Mr Churchill's parting words, addressed apparently to the air rather than to anyone in particular, were friendly enough: 'Well, not too bad', he said with a smile. Obviously he was feeling none the worse. The present collection of his mature work renders further experiments in criticism unnecessary, thank God! Our Statesman, Artist and Historian has stuck to his guns and shows us all how, by dis- regarding the wiseacres and the lures of Fashion, he has, as if by pure instinct, put into practice what surely must be the basic principle of the Masters: 'to thine own self be true. . .'

I met Sir Winston often since, and at the suggestion of friends conceived the idea of painting his portrait, to which he

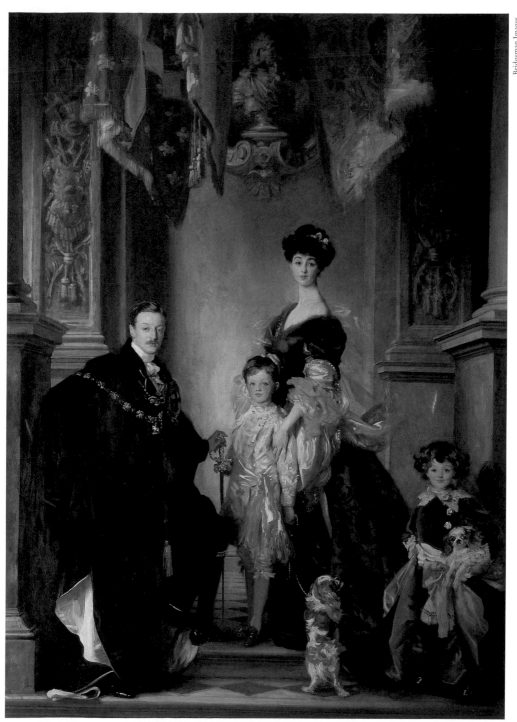

Bridgeman Images

33. The ninth Duke of Marlborough and his family, 1905. A sumptuous painting by John Singer Sargent, but it could scarcely compensate for the loss of so many Blenheim Old Masters at the sales that had taken place twenty years before.

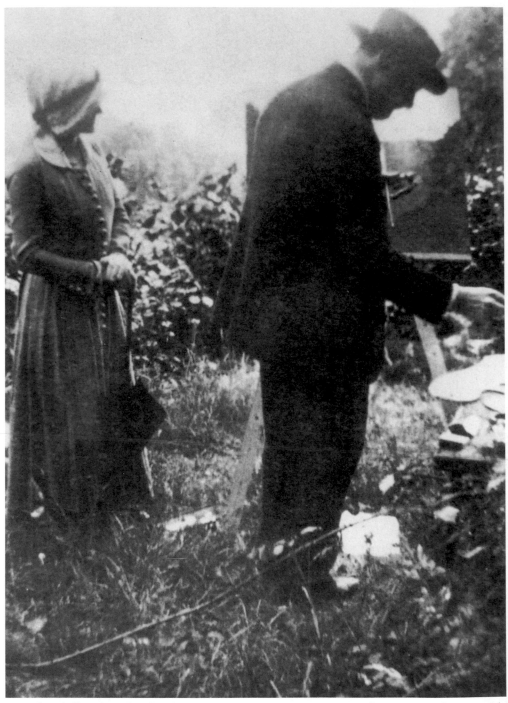

34. Churchill making his first forays into painting at Hoe Farm in the summer of 1915, with Clementine looking on.

Getty Images

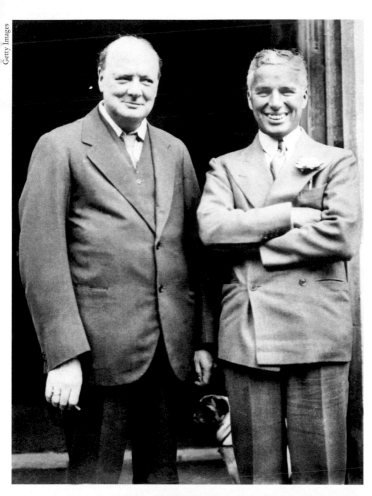

35. Churchill and
Charles Chaplin
at Chartwell in
1935. Churchill was
fascinated by the
cinema, and admired
Chaplin's work,
but the two men's
political views were
very different.

36. The Marlborough
pavilion at Chartwell,
built as a summer
house during the mid-
1920s, and decorated
in 1949 by Churchill's
nephew, John.

National Trust, Chartwell; Jon Primmer

Getty Images

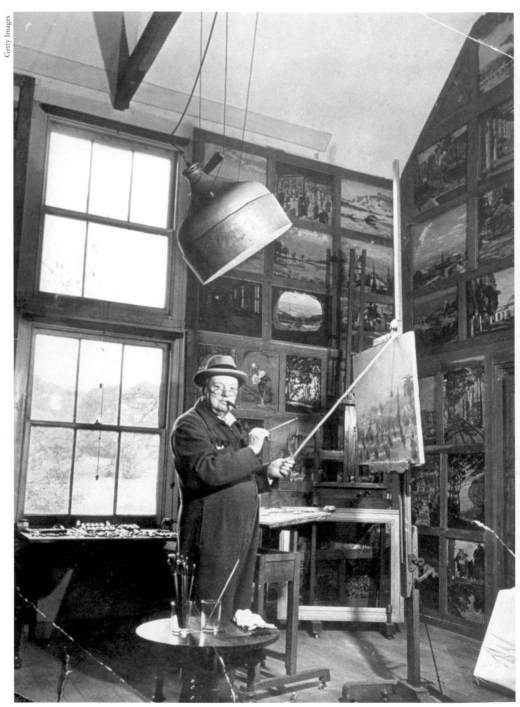

37. Churchill and canvasses in his studio at Chartwell in 1945.

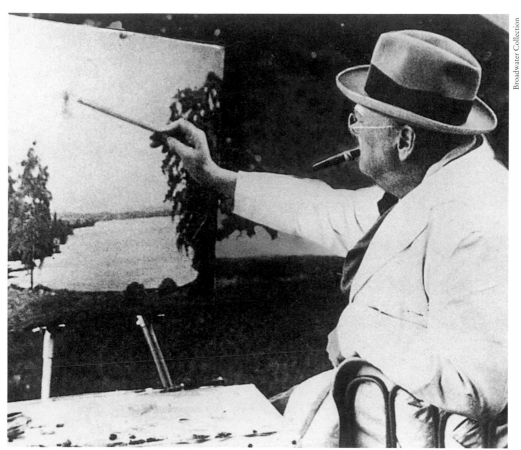

Broadwater Collection

38. Churchill painting at the Villa Choisi on the shores of Lac Leman in Switzerland in August 1946.

National Trust, Chartwell

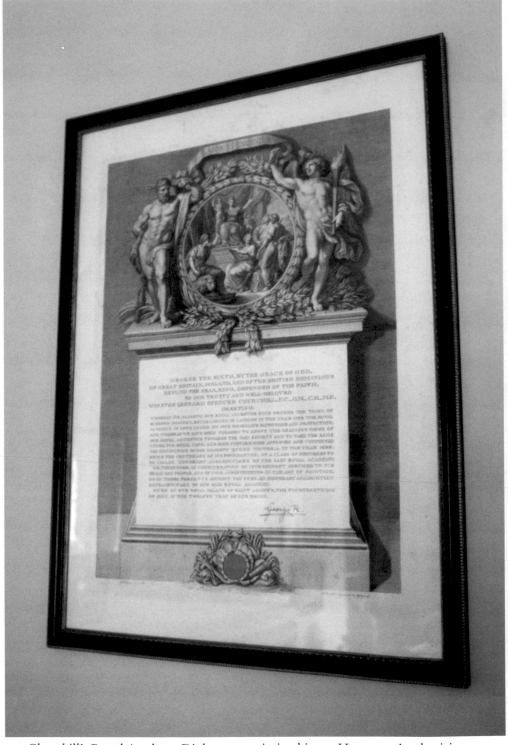

39. Churchill's Royal Academy Diploma, appointing him an Honorary Academician Extraordinary in 1948, 'in consideration of your eminent services to our Realm and People, and of your achievements in the Art of Painting.'

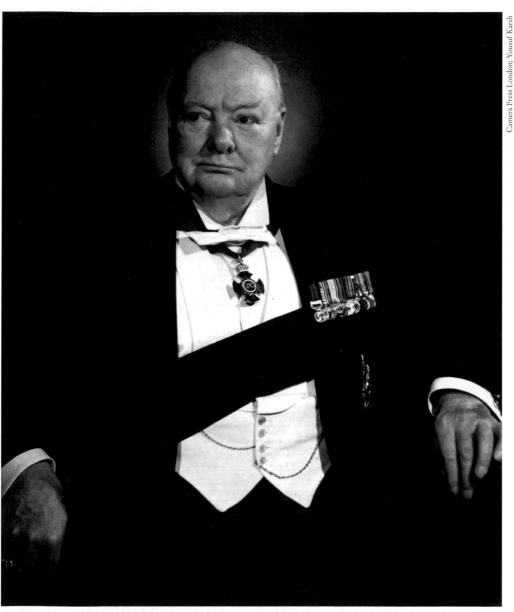

Camera Press London; Yousuf Karsh

40. Churchill photographed by Karsh of Ottawa at the Royal Academy banquet in the summer of 1956: full of years and honour, wearing the Order of Merit around his neck, and the sash and star of the Order of the Garter.

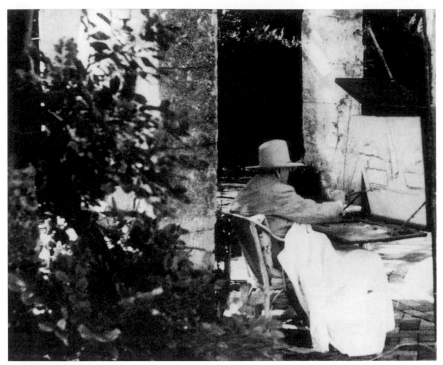

41. Churchill painting at La Capponcina in 1960. But by then his years as an artist were almost over.

Bridgeman Images

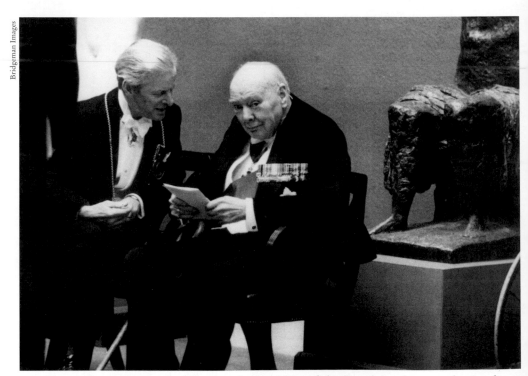

42. Churchill and Sir Charles Wheeler, the President of the Royal Academy, at the Academy banquet in the summer of 1963, the last which he attended.

agreed. But now another war intervened and this project had to be shelved. Wholly immersed in the military situation he had no time to indulge me in my 'hobby'. (As for me, thoroughly unmartial, I would as soon watch a Test match as pretend to follow the evolutions of immense armies of whatever colour.) With the ending of the war came my chance! My daughter Poppet and I jumped into the car, kindly sent to fetch us by the PM, only to find an unexpected fellow-traveller within, in the shape of an MP who shall be nameless. He had lately invaded Chelsea, in the Labour interest, I suppose, although he appeared to enjoy the friendship and hospitality of some of the most distinguished notabilities of the opposite party from the Prime Minister downwards. Gilbert Harding might have described him as 'human, with strong animal connections'. But then Gilbert Harding was a schoolmaster.

During our journey to Chartwell, this gentleman did his best to prepare us for the memorable day which lay before us, which he claimed to be the outcome of his friendly offices with Winston Churchill. In spite of this assurance, I feel bound to record that when, at the end of luncheon, a bottle of brandy was produced, it was shared strictly between the Prime Minister and myself without the participation of anybody else. (It was the best brandy.) After an hour's uncomfortable sitting in the morning, the luncheon had been delightful, and was only marred by the absence of Mrs Churchill, to whom I am devoted; but her daughter, Mrs Soames, was at my side instead and proved to have inherited her mother's beauty, charm and good nature in full measure. Young Captain Soames was also present. He had previously drawn my attention to a full-length portrait of his father-in-law by William Orpen (a fellow student of mine at the Slade),

pointing out that the preternatural gloom in which the fami-lar features were enveloped denoted in masterly fashion the heavy burden of responsibility his model was labouring under during the sittings. These included, it would seem, some of the blackest days of the first world conflict.

Although I have recorded these contacts with Winston Churchill in some detail elsewhere, I cannot refrain from returning to the sequel of the luncheon party. At a sign from my host I followed him back to the studio. We were both in better spirits after the break, and I would have been ready to resume the drawing so painfully begun in the morning. But this was not Winston's intention. Seizing a large canvas he placed it on his easel and, telling me to watch him closely, rapidly sketched in the outlines of a typical Swiss landscape with mountains, lake and the usual chalet. It appeared he had come across a new kind of paint on sale in Switzerland called 'tempera' which suited him perfectly. The colours, which could be diluted with water, were bright and their permanence was guaranteed. To illustrate their use, Mr Churchill set about completing his land-scape, which he did in no time, only omitting, by inadvertance, the central window of the chalet which I thought called for a few touches. I drew his attention to this oversight, which he admitted at once, and, standing a yard or two from the canvas, raised his brush, now richly charged with the necessary pig-ment, took aim, and then with one stride forward, BANG! the operation was over; he had scored a perfect bull!

It was now time to leave, but not before my pockets had been filled with 'tempera' colours and a handful of special brushes to go with them. With these gifts and smoking a magnificent cigar, I bade farewell to my great and dauntless friend and colleague. Long may he thrive!

<div align="center">

5.

'A RECOGNIZABLE INDIVIDUALITY'

Thomas Bodkin

1959

</div>

AN HONEST CRITIC COMING to appraise the 61 pictures by Sir Winston Churchill now on view at Burlington House should try to put out of mind all the other multifarious achievements of their painter, and ask himself if the Royal Academy, when creating Sir Winston an Honorary Academician Extraordinary, did so primarily as a tribute to his artistic prowess. The answer must be that his great gifts for the practice of pictorial art would not seem by themselves alone to have justified that decision. The distinction is a unique one; and there are many of his colleagues among the Academicians who paint landscapes with greater skill and more intense emotion.

Yet it would be a great mistake to regard Sir Winston's pictures as works which fail to reach a high professional standard. Judged by any fair test, he has to be regarded as a serious and accomplished painter who has won, on his merits, the right to take a place among the ranks of his professional colleagues. He has always been scrupulously anxious to avoid incurring the charge that partiality has been exercised

in his favour. The first two pictures which he submitted to the Selection Committee of the Academy were sent forward in 1949 under the pseudonym David Winter; and they were accepted and hung before his real identity was divulged. One of them, 'The River Loup', now represents him in the Tate Gallery and is lent thence to Burlington House. Since then Sir Winston has exhibited forty three paintings to the annual Summer Exhibitions. Most of these were painted many years previous to their first public appearance, for he ceased to paint during the war years. The earliest goes back to 1916. Even so, he was a late starter, for he was then forty two years of age. But he got quickly away, and a little painting, 'Headquarters, Lawrence Farm, Plug Street', which was done while he served as a fighting solder in the First World War, shows that he had already acquired a sound technical competence. It is the first picture which the visitor sees when he enters the exhibition. Sir Winston still practises his art, and brought back four large canvasses from his recent holiday. Having been privileged to see his collection at Chartwell, I should judge that it amounts to at least five hundred items. That is a total which comes to more than the average professional's output during a full working life.

Though Sir Winston eagerly sought advice from other artists in the early years of his practice, he was never an imitator of any other man's style; and a recognizable individuality permeates this whole exhibition. A faint suggestion of an admiration for Monet may appear in the 'Rocks near Cannes' or a reminiscence of Sir William Nicholson's painterly ease in the 'Black Swans at Chartwell', yet there is nothing imitative or directly derivative in any of these sixty one canvasses. 'Winter Sunshine, Chartwell', painted

so far back as 1924, is an astonishingly individual thing. Its painter entered it anonymously for a competition for works by amateur painters to be judged by Sir Kenneth Clark, Sir Joseph Duveen and Sir Oswald Birley who, while wondering if it might not be a professional work, agreed to award it the first prize. It was subsequently signed with a full signature, a distinction which it shares with the fine landscape 'Cork Trees near Mimizan' painted in the same year. As a rule, Sir Winston does not sign his pictures, though a few of them for which he seemingly has a special preference bear the initials W.S.C.

The core of this exhibition consists of the thirty five pictures which have recently returned from a tour of Canada, Australia, New Zealand and the United States of America. To these have been added twenty six, mostly from the artist's studio. So, if he has kept his own countrymen to the last, he has made up for this by giving them more to look at. As he is inclined to be a little diffident about the merits of his painting, it may well be that he wished his work to be tried out abroad, before putting it on view at home. Its display overseas brought about the breaking of records for attendance in many galleries, and it should have a similar result in London.

The subject matter of Sir Winston's chief predilection as a painter is landscape. He has painted no portraits [sic]; and few of the landscapes contain figures, though 'Le Beguinage, Bruges', done in 1948, shows how well he can draw and place figures in a landscape setting when he chooses to do so. This is lent by Miss Hamblin, one of the very few private persons privileged to possess a picture by him. The Duke of Sutherland lends a very early one of 'Loch Choire', Lady

Birley, 'Les Zoraides, Cap Martin', showing the reflection of a house in a pool, and his publisher, Mr Emery Reves, a dashing group of three trees on a cliff, painted quite recently and humorously entitled 'Custody of the Child'. For the rest, Sir Winston prefers to be his own collector; though Lady Churchill lends three notable tributes of his affection: 'Cork Trees near Mimizan', 'Flowers', a crystal vase of brilliant blooms, and 'Bottlescape', the still-life of bottles, wine-glasses and cigar-boxes which was painted in 1932 and excited much admiration for its dashing virtuosity when it appeared in 1955 at the Annual Summer Exhibition of the Academy. The cover of the well illustrated guide-catalogue of the show is adorned with a good colour-reproduction of 'Magnolia' lent by his daughter Mary, Mrs Christopher Soames, who is also the fortunate possessor of 'Tapestries at Blenheim', one of his few interiors, often reproduced and said to rank among his favourites.

The collection is well arranged in the North and South Rooms of the Dipio Gallery. Each picture is labelled with its title and the approximate date of its execution. Their order is not chronological. The general effect is high in tone and bright in colour. But there is nothing to suggest that Sir Winston's style can be segregated into periods. It came to sudden maturity and shows neither advance nor regression with the passing of the years. If some pictures seem more impressive than others, that is probably because he was able to give more time to them. Thus the 'Torcello', done in 1949, and the 'Venice', done in 1951, look a little too cursory and inchoate. He seems to have been able to spend longer time on such magisterial compositions as 'River Scene, France', which curiously is one of the few not reproduced

in the catalogue, and the 'Valley of the Ourika and the Atlas Mountains'.

Were I to be given my choice of them all I think I should opt for the 'Black Swans at Chartwell', obviously a theme after its painter's heart, ingeniously designed and lovely in colour. All else being equal, the pictures that will surely give people most pleasure are those which have close personal associations with the great man: 'Snow at Chartwell', 'The Goldfish Pool', where he has so often come to throw grain to its glittering denizens in his hour of relaxation, or 'Chartwell Kitchen Garden', bounded by the brick wall that he built with his own capable hands in the middle of the fair countryside of Kent.

6.

'A GREAT PRESIDING PRESENCE'

John Rothenstein

1970

I T WAS AN EXTRAORDINARY experience, this first visit
to [Churchill's] studio at Chartwell [in February 1949],
above all because of the combination in the artist's tempera-
ment of extremes of humbleness and confidence. I learnt to
refrain from too positively constructive comment in case he
should impulsively put it into effect – he evidently splashed
down paint without any inhibition at all, and used whatever
aids he judged most appropriate to the work in hand. He
preferred to work direct from his subject (and an open-air
subject for choice), but he worked on occasion from photo-
graphs and even had negatives projected on to sensitized
canvasses. The paintings he showed me were energetic,
yet they lacked intensity, and he was prone to an excessive
use of acid greens. When I observed that the effect of these
greens was sharpened by the chilly elephant-grey frames
he favoured, he said that I must come to see him in London
to discuss the whole problem of framing; but would I there
and then choose some paintings for the Summer Exhibition
at Burlington House. When I had done so he gave me a
puckish look and said, 'Certain of your choices coincide
with those of Sir Alfred.' Then we talked about prose style.

'People are sometimes shocked by my use of slang,' he said, 'but the shortest words are usually the best – and the simplest constructions.'

Churchill behaved as though I had done him a favour by coming to Chartwell. 'It was awfully good of you', he said, 'to have helped me by giving me so much of your time.' Then a double whisky was brought in to fortify me on my homeward journey and the arrival of the taxi to take me to the station was announced. 'There's plenty of time,' he said, 'and there are one or two more of my daubs I'd like to show you.'

When I asked the taxi driver whether we were going to catch the train he said, 'It's always the same, so I give visitors a bit of extra notice.'

As I was leaving he asked me whether I would do him the honour of accepting a copy of his *Painting as a Pastime*. Upon my saying that I should be delighted, he sent his soldier servant to bring one from a place which he designated. On his return with a copy Churchill said irritably, 'No, not one of those; one of the *special* copies.' When it was explained to him that there were no special copies left at Chartwell, he did not offer me that which had been brought, but a few days later a 'special' copy, inscribed and beautifully bound, arrived for me by post.

At the Academy Dinner that year Munnings had associated Churchill with a storm of abuse he directed at 'modern art' in general and Picasso and Matisse, also Henry Moore, in particular, saying that he and Winston were walking in the street and Winston had said to him, 'If we met Picasso or Matisse we'd give them a running kick, wouldn't we?'

Not until the following spring did I pay another visit to Chartwell. In the meanwhile, at the suggestion of one of his friends, I had written a brief appreciation of Churchill as

an artist.[1] In view of the privileged circumstances in which I had come by my knowledge of his work, it was of course out of the question to publish it without his consent. I accordingly sent him a draft, and shortly afterwards there came an invitation to spend 11 March at Chartwell. The prospect of going over the draft with the subject of it was one that I did not relish at all. I was not sure whether he had read it, but he gave me leave to publish it. 'I just hoped you'd come here for a talk and once again I'd be most obliged for your advice on what I should send this year to the Academy.'

I at once asked him whether there was any truth in the remarks that Munnings had attributed to him about kicking Picasso and Matisse. 'Quite untrue', he said. 'I was angry. I wrote to Sir Alfred. All quite untrue, and besides, *I never walk in the street.* Speaking of Presidents of the Royal Academy,' he asked, 'what sort of man is Kelly?' (who had recently succeeded Munnings).

On my previous visit to Chartwell I had been alone with Churchill, but on this occasion there was a family party, Mrs Churchill, their son Randolph, and Mrs Esmond Romilly, besides his friend William Deakin (who had helped him with research in connection with his book on Marlborough). After lunch he took me off to his studio and we went through his pictures. 'There's nothing quite recent,' he said, 'as I've been unable to paint during the election' (the recently held election at which the Conservatives had been returned to power with himself as Prime Minister).

On the whole he showed little judgement about his own painting (which means no more than that his assessments differed from mine), and he seemed equally surprised by the objects of my praise and censure. There was a landscape we

were agreed about in which he had tried, and with success, to capture 'the emanation of light over water', but about another canvas, a still-life with a figure of Buddha, which he called 'Life and Death', we differed sharply. He was pleased with it and told me that it was his firm intention to send it to the Summer Exhibition, to which I replied that it might win him popular success but it would not add to his reputation as a painter. Nothing I said diminished his satisfaction, and off the picture went to Burlington House.

[On 25 March 1954 I visited Churchill at Downing Street.] It seemed natural to find him in his blue siren-suit and initialled slippers at Chartwell but incongruous at No. 10 – incongruous but none the worse for that. 'Once again,' he said, 'I should be much obliged if you would help me select four works for the Summer Exhibition. They're putting pressure on me to send more, but I won't.' Among the four we selected was an energetic landscape, made recently on the south coast of France. 'This, and one other, was done in oils over a tempera base,' he explained, 'in only two hours – after my stroke.' Among the works that I particularly admired was one of an orchard; my admiration, Churchill told me, was shared by Gerald Kelly, but he thought little of it himself.

In the meanwhile we were looking through stacks of canvasses and once again we examined one of his two recent landscapes, two big trees blown about by a high wind, and a small tree between them: 'Look!' he said, 'they're hitting each other properly, aren't they? And there's the little neutral, or a child perhaps, his parents are fighting over. I think I'll call it "The Custody of the Child".'

Five days later I was again invited to No. 10 Downing Street. The Prime Minister was much preoccupied with

the south-of-France landscape that we had discussed on my recent visit. He had carried out the modifications to the sea and the rocks which, under heavy pressure from him, I had suggested, and he had decided, on further consideration, to title it 'A Family Quarrel' – 'just look at the way they are hitting one another,' he said gleefully, pointing to the boughs, tangling as they were bent by the wind. 'I might', he remarked suddenly, 'hold a one-man exhibition after I retire.' When I asked him how President Eisenhower painted he said, 'Ike paints pretty well: how I wish he and I might set up our easels side by side.'

As we looked together at his paintings he sought repeated assurances that those we had selected on my previous visit were fit to go to the Summer Exhibition. He did not follow his usual habit of seeing me to the door, but instead bent over the first of the canvasses to go in order to sign it. 'This paint', he zestfully observed, 'is the blackest black.'

While I was still in bed on the morning of 3 March [1955], Churchill telephoned to ask whether I would come to Chartwell the next day; in order to be able to do so, I postponed until the following night a projected journey to Scotland. Next morning I found him dissatisfied to the point of anxiety by Professor Richardson's proposals for his representation at the Summer Exhibition that year. I was not surprised, for all five canvasses were trivial little bits of good taste, none of them affording a hint of the energy and closeness of observation that marked his best work. One of the five Professor Richardson had suggested should be trimmed, which further disturbed Churchill. Together we chose instead some more robust and characteristic works, to his manifest relief.

After lunch Churchill suggested we should look at his paintings (with all of which I supposed myself already familiar), but instead of taking me back to the house he led me – past a wall and a cottage which he had largely built himself – to an outbuilding where I had never been before. (For our walk he wore, over his siren-suit, a white overcoat with a light fur collar.) The interior walls of this place were entirely covered with his paintings, to which in our many conversations about his work he had never alluded. Among these were some of his most interesting canvasses, including two pictures of trees seen through drifting mist, made at Roehampton about 1919; also a self-portrait, as well as portraits of Arthur Balfour and his sister, done from photographs. The two mist-veiled trees had a magical touch, to which he himself, however, seemed entirely unresponsive. Later we returned to the house to reconsider the works provisionally selected for the Summer Exhibition. He was eager to show the spirited wind-buffeted trees that I had seen the year before, and now definitely christened 'The Custody of the Child'[2]; as well as an ambitious but, to my thinking, unsuccessful 'Bottlescape', of 1932.

Ever since I had come to know Churchill's painting I had been convinced that we should have an example at the Tate. I readily admit that the thought entered my mind that it would be an acquisition fascinating in the way in which, for instance, a landscape by the Elder Pitt would be, but the chief consideration was that if one of the very best could be secured, it would be an acquisition worthy in its own right. This last consideration was crucial, for Churchill was an untaught and often an impetuous artist, whose way of life involved continuous interruption of his painting; only

a small proportion of his pictures therefore seemed to me worthy of a place in the national collection. Up to that time he had retained by far the greater part of his production, and his best pictures were still almost all in his own possession. If for any reason this situation were to change, and his pictures to be scattered, it might have become impossible to obtain one of the very best, in which case I would have felt bound to advise against his representation. In May 1955 I submitted these considerations to the Tate Board, and it was agreed that I should explore the possibilities of making a purchase, the Board considering that his resignation as Prime Minister removed an obstacle to his representation. I accordingly wrote about the matter to Churchill, who invited me to Chartwell for 18 July.

My host welcomed me still wearing his dressing-gown, then left me to look through a long rack of his paintings, situated in an upstairs room recently equipped as a studio, the big room where he formerly painted having been converted into a drawing-room. At lunch he seemed at first apathetic and deaf. After a few moments his interest was aroused and he became cheerful and animated. I had told the Trustees that I had somehow formed the impression that he would either decline to allow the Tate to acquire one of his pictures, or else he would offer to present one. The Trustees proved wiser than I, for it quickly became apparent, if matters were to be brought to a conclusion, that it was essential that the Gallery should offer to buy a picture. It was not less apparent that he was unwilling to sell, but that, assured of the Trustees' willingness to buy, he would be happy to present one, provided that he was assured that extraneous considerations had no part in our interest in his work.

I explained that while I believed he was aware of my own long-standing admiration, the Trustees had been naturally sensitive about making an approach to the Prime Minister to whom several of them owed their appointments. At this he grinned broadly and said, 'So you think it's all right, do you, now that I've been kicked out? Not', he continued in a grimmer, almost challenging tone, 'that they could have forced me to go before I wanted to.' When asked whether there were not great compensations in freedom from public responsibilities that left little time for private pursuits, he gave a doubtful grunt.

On the morning of the following Thursday, 21 July, I was deep in the complex preparations for the afternoon's Board Meeting when [Churchill] telephoned, asking me to go to see him as soon as possible at his London house, 28 Hyde Park Gate. I found him in bed smoking an immense cigar; a box containing others stood on his bedside table. He had been giving much thought, he said, to the selection of his paintings for consideration by the Tate and he asked me to tell the Board of his own strong preference for 'The Loup River, Alpes Maritimes'. When I remarked on the absence of 'The Orchard', which he had promised on Monday that the Board should at least 'see' – though it was understood it was not to be his sole work in the Gallery – he said emphatically, 'I can't let that be seen in any circumstances.' It was most singular, this aversion to one of his most beautiful pictures. The reason for his change of intention may not have been aesthetic: I gathered that Gerald Kelly had tried to secure it for the Dulwich Gallery, but that Churchill had refused to part with it; and he possibly felt that to let it go to the Tate might have offended Kelly. 'I'll sign whichever picture your

Trustees accept. And I should be most obliged if you would let me know their decision by telephone this evening.'

After the Board Meeting I telephoned to tell him that 'The Loup River' had been accepted, and with the utmost pleasure. This painting, in my opinion one of his best, was made in 1930, the site lying about 500 yards from where the main Cagnes-to-Grasse road crosses the river, and it exemplifies his unusual perception of light effects over water.

On my return to London on 23 February 1956, from a visit to the United States, I found an urgent message from Churchill asking me to go down to Chartwell the very next morning. Sir Winston seemed indifferent and infirm, but as on other occasions his spirits revived over lunch, and before it was half through he was alert and genial as ever. Always retentive of matters that had annoyed him, he referred, although without mentioning Munnings by name, to his association of himself with abuse of Picasso and Matisse, and as though by way of an additional repudiation he described how on a recent visit to France he had been studying books on Cézanne, Van Gogh and certain of their contemporaries and had even made some copies of illustrations of paintings by Cézanne.

During his last years I had the privilege of Churchill's company less frequently, partly, I believe, because for one reason or another he had not been able, in retirement, to realize his ambition of giving more time to painting. Almost invariably after the Academy Dinner he sent to ask me to accompany him round a part of the exhibition. In the course of such a perambulation in 1956, when Munnings had embarrassed his fellow Academicians by releasing to the press a statement that this was the worst Academy ever, dominated by 'young brutes', and that he declined to attend the dinner,

Churchill told me that he 'sharply disapproved', also of my inclusion in what Munnings called a 'satiric' picture – a harmless but silly caricatural conversation piece which he showed that year.

In the course of another such perambulation after the dinner the following year, he asked me abruptly, 'Are the President and Council *bound* to accept *any* work submitted by an RA?' I told him that I understood that they rarely exercised their right of exclusion. Then he began to speak about his portrait by Ruskin Spear hanging in the exhibition, which he obviously disliked, and when somebody came up to talk to him he evidently still had much to say about it; later on I saw him refuse to shake hands with Spear.

I count this intermittent yet years-long association with Churchill as one of the great privileges life has accorded me. It was in one respect at least a singular relationship, in that in spite of his extraordinary candour and the warmth of his friendliness I do not believe that I ever came to know him very much better. His mannerisms, his way of life, as well as certain experiences that inflicted lasting wounds, certain affections and aversions, I certainly came to know, but about the deeper operations of his mind I understand little more than I did at the end of that first day at Chartwell in 1949. Of one of his attributes I would like to make particular mention: his extraordinary and unvarying consideration and courtesy.

On 24 January 1965 the news that Churchill had died shortly after eight in the morning was broadcast at nine. We listened to this and to Beethoven's Fifth Symphony that followed it. I found tears in my eyes. We knew how very ill he was; that his memory had failed and death was merciful.

A few Sundays earlier Cyril Connolly had written of T. S. Eliot, who died on 4 January, that he had liked the feeling that he was around. I felt that about Churchill and so, I imagine, did all Britain. A great presiding presence was no longer there.

The funeral took place six days afterwards. Today so much of the finest art, however widely appreciated, is of a private character, addressed to a comprehending few. Churchill's funeral, on the contrary, was a superbly contrived public work of art, dignified, splendid, tender, ingenious: the sudden unexpected singing in St. Paul's of 'The Battle Hymn of the Republic'; the bowing cranes on the South Bank of the Thames as the boat carrying the body passed by. By evening he was lying not many miles away in Oxfordshire earth.

NOTES

1 Included in this book, pp. 139-44.
2 This picture when shown in a retrospective exhibition of his work at Burlington House in 1959 was dated 1956 (instead of 1954) in the catalogue.

ACKNOWLEDGEMENTS

The following are reproduced by kind permission of the copyright holders.

Copyright information for artworks can be found in the List of Illustrations.

PART ONE: CHURCHILL ON ART
Written works of Winston S. Churchill Copyright © The Estate of Winston S. Churchill 2018

PART TWO: ON CHURCHILL'S ART
Eric Newton, 'Churchill: Painting a Picture is Like Fighting a Battle', review of Winston Churchill's *Painting as a Pastime* from the *New York Times Book Review*, 12 February 1950. Reprinted by permission of Josephine Hammond.

Thomas Bodkin, (1953), 'Unity, Vitality, Infinity and Repose' ('Churchill the Artist') from *Churchill by His Contemporaries*, ed. Charles Eade, London: Hutchinson.

John Rothenstein, (1954), 'Gay, Brilliantly Coloured Canvasses' ('The Artist') from *Winston Spencer Churchill: Servant of Crown and Commonwealth*, ed. Sir James Marchant, London: Cassell. Reprinted by permission of Lucy Carter.

Augustus John, (1959), Unpublished foreword to the Royal Academy catalogue. Reprinted by permission of the Estate of Augustus John.

Thomas Bodkin, 'A Recognizable Individuality', Review of the Royal Academy's 1959 Churchill exhibition, from the *Birmingham Post*, 11 March 1959. Reprinted by permission of Trinity Mirror.

John Rothenstein, 'A Great Presiding Presence' (1970), extract from his autobiography *Time's Thievish Progress*, London: Cassell. Reprinted by permission of Lucy Carter.

INDEX OF NAMES

A NOTE ON THE TYPE

The text of this book is set in Bell. Originally cut for John Bell in 1788, this typeface was used in Bell's newspaper, *The Oracle*. It was regarded as the first English Modern typeface. This version was designed by Monotype in 1932.

A NOTE ON THE AUTHOR

Professor Sir David Cannadine is Dodge Professor of History at Princeton University, Editor of the *Oxford Dictionary of National Biography* and President of the British Academy. His numerous publications include *The Decline and Fall of the British Aristocracy, Class in Britain, In Churchill's Shadow, The Undivided Past, George V, Margaret Thatcher: A Life and Legacy* and *Victorious Century: The United Kingdom 1800–1906*.